Renoir

Renoir

William Gaunt

with notes by Kathleen Adler

Phaidon · Oxford

Phaidon Press Limited, Littlegate House, St Ebbe's Street, Oxford OX1 1SQ

First published 1962
This edition, revised and enlarged, first published 1982
© 1982 Phaidon Press Limited

British Library Cataloguing in Publication Data

Gaunt, William
 Renoir. —3rd ed., New enlarged ed. —(Phaidon
 colour library)
 1. Renoir, Pierre Auguste
 I. Title II. Renoir, Pierre Auguste
 759.4 ND553.R45

 ISBN 0-7148-2229-9
 ISBN 0-7148-2242-6 Pbk

Typeset, printed and bound in Singapore, under co-ordination by
Graphic Consultants International Private Limited

The publishers wish to thank all private owners, museums, galleries and
other institutions for permission to reproduce works in their collections.
Particular acknowledgement is made for the following: Plate 1 — Cour-
tesy of the Fogg Art Museum, Harvard University, Cambridge, Mass.
Bequest — Grenville L. Winthorp; Fig. 1 — Courtesy of the Fogg Art
Museum, Harvard University. Bequest — Collection of Maurice
Wertheim. Plates 9, 30, 39, 45 and Fig. 33 — Reproduced by courtesy of
the Trustees, The National Gallery, London. Fig. 28 — Photograph
Copyright (1982) by The Barnes Foundation, Merion, PA. Fig. 11 —
Allen Memorial Art Museum, Oberlin College, Ohio. R. T. Miller, Jr.
Fund, 48.296. Plates 3, 12, 20, 25, 26, 31, 37, 42, 47, 48 and Figs. 4, 6, 7,
15 and 34 — Musée du Louvre, Paris. Fig. 23 — Museum of Art,
Carnegie Institute, Pittsburgh, Pennsylvania; Acquired through the
generosity of Mrs Alan M. Scaife and family, 1965.

Renoir

Renoir ... the name of the great French painter (in itself like a sigh of pleasure) calls up an entrancing world in which the women and children are entirely captivating, the sun-flushed bathers, splendid of body, seem to belong to a new golden age, the landscapes shimmer with intoxicating light and colour, the everyday scene the artist knew is endowed, by his perception, with a wonderfully joyous and gracious life.

He is born into the nineteenth century, yet he has banished from it all that is stern and sombre, awkward and ugly. This is the effect of a temperament, an outlook, he shares, in some degree, with other members of that remarkable group with whom he is associated, the Impressionists, whose concurrence is so beautiful an episode in the history of art. His creativeness, however, is not confined by the formulas of a 'movement'. He is like an artist of the eighteenth century, of the time of Boucher and Fragonard, reborn in the bourgeois epoch. He admires and conserves, it is the nature of his gift to express, the exquisite refinement of the French tradition. On the other hand he marches forward into the twentieth century; his art in his old age, when, though crippled in body, he is more vigorous than ever in spirit, puts out new and rich blooms.

To trace this magnificent evolution let us first mentally transport ourselves to Paris of a little more than a hundred years ago and enter the workshop of a china manufacturer in the rue du Temple.

Here, in 1854, sat Pierre-Auguste Renoir, a slight, brown-eyed boy, thirteen years of age, industriously painting sprays of flowers on the smooth white surface of cup and saucer. It was his start in life, for which he had to thank the peculiar respect the porcelain industry inspired in his parents. They came from Limoges, where porcelain stood for prestige and prosperity. In their view it offered an ideal niche for a son who wished to be an 'artist'. The father of Pierre-Auguste, Léonard Renoir, was a 'modest artisan', a struggling tailor, that is, who had been unsuccessful in Limoges and in middle age had come, with wife and children, to try his luck in the capital. Pierre-Auguste was born in Limoges in 1841, but as the move was made when he was only four he had no memories of his native city and never again set foot there.

To all intents and purposes he was a young Parisian of the working class. It would seem that the first known Renoir of the line (Francis) was a foundling, but born in 1773, married in the revolutionary Year IV (1795), becoming the father of Léonard in the Year VII. The first impressions of our Renoir were of humble

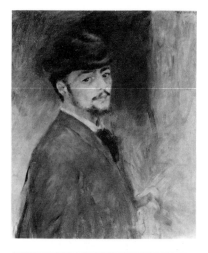

Fig. 1
Self-Portrait

OIL ON CANVAS, 73 × 56 CM. 1876.
CAMBRIDGE MASS., FOGG ART MUSEUM

quarters in the rue d'Argenteuil. He went to the state school, where the choirmaster of St Eustache, Charles-François Gounod, who gave music lessons (he was not yet famous as a composer), picked him out as one with the makings of a singer: but the symptom familiar in the early life of most artists showed itself. He covered the pages of his exercise books with drawings; his parents gave his bent as practical a turn as possible and in the rue du Temple he made his début as a kind of painter.

It was not work of a high order; the decoration of the pieces (intended for export to eastern countries) was paid for at the rate of sixpence a dozen. Nevertheless it required and fostered a precise use of the brush, a delicate touch and an appreciation of quality in the glaze of bright colour on its smooth white ground. For four years the young Renoir was an industrious apprentice in the art and craft of porcelain painting, progressing in design from the simple flower to the portrait of Marie Antoinette. It gave him, no doubt, the pride of craft. Something of its fine technique remains, or reappears, in his mature style; yet other and greater influences were already at work. The rue d'Argenteuil was near the Louvre and he slipped in as often as he could to gaze at its masterpieces. Released from the factory at lunchtime, he discovered one day the *Fontaine des Innocents* by the sixteenth-century sculptor Jean Goujon and walked slowly round and round it (absent-mindedly chewing his morsel of *saucisson*) absorbed in the grace of the sculptor's conception, the solidity of form that yet allowed one to see the very grain of the flesh. It was at the age of seventeen that he gained a special intimacy with the elegant court painters of the past.

At this moment the introduction of printed designs on pottery drove Renoir's employer out of business — a sharp lesson Renoir never forgot in the enmity between modern industry and handicraft. He took to painting fans for a living, with copies of pictures from the Louvre by Watteau, Lancret, Boucher and Fragonard. Time and again he reproduced the gallants and ladies in the rich landscape of Watteau's *Embarking for Cythera*. All his life he was to love Boucher and Fragonard, in whose joyousness of feeling he now discovered an affinity with his own feelings as an artist. How well Boucher understood the beauty of woman, the softness of contour, the suppleness of limb.

These loyalties throw a light on the mature work of Renoir, which makes it easier to understand why he has been called 'a great eighteenth-century painter born a hundred years late'. In spirit, the youthful painter of fans already belonged to the vanished age of elegance, though between the ages of seventeen and twenty-one he had to find his way through a good deal of modern drudgery. For a

long time it seemed impossible to be a real painter. A fellow-worker in the porcelain factory who dabbled in his leisure hours had encouraged him to take to oils and canvas and had spoken with warmth to Renoir's parents of the result, but the francs had somehow to be brought in by other means. In addition to the fans, he copied or adapted some heraldic designs for his elder brother, a *graveur en médailles*. He decorated a café. Finally he got a job with a manufacturer of window blinds who supplied missionaries with material, painted to imitate stained glass and thus give to some hut in the tropics the illusion of a church interior. He saved money enough to live on for a while and take up the study of painting in earnest. At the prompting of his friend Laporte he decided to go to the Atelier Gleyre: and there at the beginning of the 1860s he made his real start.

It was a free and easy institution, this atelier of Charles Gleyre, a mediocre Swiss painter who had taken it over as an art school from another mediocre painter, Delaroche. The teaching was casual; once a week or a fortnight, the morose and ageing master put in an appearance and made his brief, weary comments. To Renoir, he observed, on one occasion, 'One does not paint for amusement,' which called forth the retort, 'If it didn't amuse me, I shouldn't paint.' In this exchange both were true to character. Gleyre, the follower of Ingres, regarded painting as a severe and formal exercise: for his pupil it was, and always remained, a pleasure. As they had nothing in common, Gleyre could be no help, and his merit, from Renoir's point of view, was that he left the student to his own devices. For the discipline of drawing Renoir went of an evening between 1862 and 1864 to the École des Beaux-Arts: yet the Atelier Gleyre was by no means useless. It had two great advantages. It was a meeting place of youth, talented, ambitious, energetic. Renoir there formed those friendships, with students of about his own age, that had a very great influence on the development of his art. The second, and related, advantage of Gleyre's was that new ideas passed to and fro. The atelier itself seemed to encourage them, in reaction against its own lifeless canons.

The intimates of Renoir were three: Claude Monet, Alfred Sisley and Jean-Frédéric Bazille. He could have found no livelier or more gifted company. Monet was already interested in the problem of bringing a new truth of atmosphere and effect into landscape. Sisley, the well-to-do young Englishman born in Paris, shared his interest in landscape (his great enthusiasm was Corot). Bazille, who came from Montpellier, where he had been a medical student, was likewise the admirer of the new nineteenth-century art with its striving towards reality.

Now Renoir became aware — of the French Revolution,

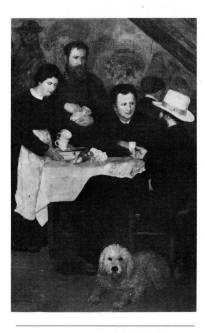

Fig. 2
At the Inn of Mother Anthony

OIL ON CANVAS, 1.95 × 1.30 CM. 1866.
STOCKHOLM, NATIONAL MUSEUM

Fig. 3 (opposite)
Diana

OIL ON CANVAS, 1.97 × 1.32 CM. 1867.
WASHINGTON D.C., NATIONAL GALLERY OF
ART (CHESTER DALE COLLECTION)

which intervened like a wall between his age and that of Boucher and Fragonard. On the nearer side of it tradition had withered, grown lifeless and false. Renoir ranged himself on the side of those post-Revolutionary artists who had defied scholastic precept — with Delacroix, who had burst through cold restraint to paint with emotion; the landscape painters of Barbizon who, inspired by the English Crome and Constable (though this the young students of Gleyre may not have realized) looked at a tree for themselves; with Courbet, the unflinching realist.

It is, broadly speaking, as a realist in the manner of Courbet that Renoir, in his twenties, first comes into view as an artist; though other influences can be discerned. He tried, apparently, a romantic subject, in his first Salon picture, the *Esmeralda* of 1864, but this he afterwards destroyed. He used the cool grey of Corot. He learned also, by his own account, something about colour from the Barbizon painter Diaz. 'Why on earth do you paint things so black?' said Diaz, who chanced upon Renoir and Sisley in 1862 on a sketching expedition in the forest of Fontainebleau. It was, however, with Courbet's eye for fact that he painted the group *At the Inn of Mother Anthony* in 1866 (Fig. 2), depicting the village inn at Marlotte just as it was, with the servant Nana, the dog Toto, and the wall decoration contributed by various *habitués* (Renoir himself added the caricature portrait of Murger on the left), introducing also his painter-friends, Sisley and Jules Lecoeur. It is a document of the sixties: as frankly as Courbet, Renoir accepted the unbeautiful male costume of the time. It offered its problem once more in the picture of Sisley and his wife painted in 1868 (Plate 5), though in this there is a charm that derives from the artist's vision, the sense of an even poignant contrast between the human and natural pose and the cumbrous dress that fashion has prescribed, a lightness of touch that turns the shapeless trousers and the weighty crinoline to decorative advantage.

'Courbet was still tradition, Manet was a new era of painting.' Thus Renoir was later to define the brilliant man who finally resolved the camp of young realists into a creative group, engaged not only in painting contemporary subjects but in giving a fresh life and intensity to the medium they used. It was long before Renoir was entirely weaned from the massive influence of Courbet. There is still a reminder of it in the *Bather with a Griffon* (Plate 7), painted when Renoir was twenty-nine; and even later (Fig. 3). Yet in the meantime other forces were at work. If Renoir was inclined by nature to suspect the 'new', yet like his friends he could not fail to be excited by the revelation of Manet's *Picnic* in the Salon des Refusés of 1863, the *Olympia* of 1865. Here was the challenge of *contemporanéité* (to use Manet's word) suggesting, if

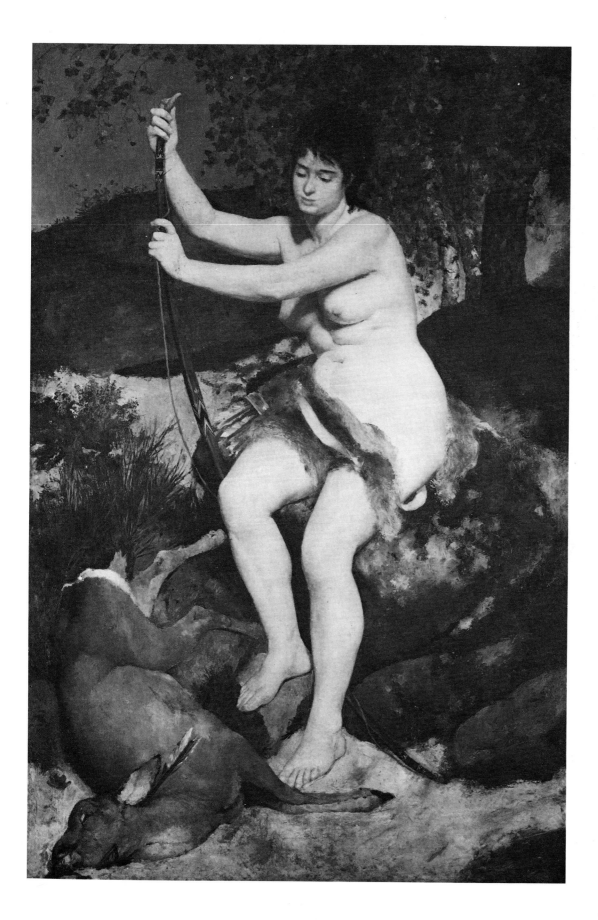

not as yet fully embodying, so many things, a method of startling directness, a release of the powers of colour and light. The younger contemporaries of Manet drew closer together, to discuss and defend him, to develop their own ideas in the light of his. It would not seem that Renoir took any notable part in those famous discussions at the Café Guerbois which led or helped to lead from the championship of Manet to the theory of painting in the open and translating light into broad divisions of primary colour. Yet he was touched by the same enthusiasm as Monet and Bazille, by that of more recent friends, Camille Pissarro and Paul Cézanne, whom he first met in that great year of refusal, outcry and debate, 1863. He absorbed something of the character that now began to distinguish them as a group. The follower of Manet appears in the *Skaters in the Bois de Boulogne,* 1868, with its bold, direct strokes of the brush: and so closely was he associated with Monet in these years that inevitably their pictures began to show points of likeness.

He and Monet painted together in the open air, with the patches of pure colour that proved so wonderfully effective (according to the recipe Monet himself had largely devised) in conveying the shimmering effect of atmosphere. They sat side by side in 1869 at the bathing-place on the Seine, La Grenouillère, studying the overhanging trees, the gay crowd of holiday-makers. The pictures that Monet and Renoir have left of the scene (Plate 6), from almost the same point of view, are gay, idyllic. For Renoir, the warm summer afternoons spent on that long curve of the Seine, on the outskirts of Paris at Bougival, Croissy, Chatou, were unmixed happiness. Summer was his season; unlike Monet, he could not interest himself in any other time of the year. 'Why' he once asked, 'paint snow, that leprosy of nature?' It was better to look at the sunlit Seine, *en fête,* its fascinating medley of people, sauntering in the open or enjoying themselves in the floating restaurant. There were superb girls among them, who could, without much difficulty, be persuaded to sit for a picture.

When the Franco-Prussian war began in 1870, Renoir was a slender, hollow-cheeked young man of twenty-nine. He was not, materially, much better off than when he was doing his hackwork for the manufacturer of window-blinds. There was a gulf in this philistine century between artist and public which it sometimes seemed impossible to bridge. This had created the 'vie de Bohème' in the ways of which Renoir had become well versed: the moves from one garret to another with meagre belongings packed in a wheelbarrow, the visits to the mont-de-piété, the casual sale to some small tradesman eccentric and exceptional enough to lay down a few francs for a useless thing like a picture.

A painter could live, perhaps, on five francs a day. At the same

time, the fifty to a hundred francs, which could with difficulty and at uncertain intervals be extorted for a canvas, did not go very far. The young men helped one another, they were an alliance against the world. In 1866 Renoir found food and lodging in the home of the painter Jules Lecoeur. Bazille, who was not badly off, came to the rescue at intervals. In a letter of 1868 he writes, 'Monet has dropped on me out of the blue with a magnificent lot of canvases. He'll sleep here until the end of the month. With Renoir, that makes two needy painters I'm housing. It's a real workhouse. I am delighted. There's room enough and they're both in very good spirits.' At intervals, Renoir retreated to the house of his parents, who now lived at Ville-d'Avray. He was there in 1869, together with Lise the model with whom he was then much taken, whose Manetesque portrait with a parasol figured in the Salon of the year before (Plate 2). Monet was almost literally starving. Renoir filled his pockets with bread from the parental table to take to his friend. There were times when he felt like giving up, for it was not his nature to go against the tide; it was then that Monet, the real fighter, encouraged him to keep on. Theirs, after all, was a cheerful misery. They were young, able to enjoy themselves, devoted to their profession and conscious of unusual powers.

Renoir had as yet produced no characteristic masterpiece, though his ability from 1864 onwards could not be in doubt. The impression made on him by others was still very obvious in his work: his personality as an artist was not completely formed. In his own estimate he was just beginning to be 'known', which implied the approval of artists rather than patrons. He looked on it as a sign of progress that Manet, a fastidious critic, spoke well of his portrait of Bazille at the easel (Plate 3): but not long after he had painted it, war abruptly broke in on the life and work of Renoir and his friends, scattering them far and wide. Poor Bazille, who had shown excellent promise as an open-air landscape painter, was killed at the battle of Beaune-la-Rolande. Renoir served in a cavalry regiment though he saw no fighting, being stationed at Bordeaux. He came back to Paris after Sedan, during the confused period of the Commune, having for a time a passport enabling 'citizen Renoir' to carry on his occupation in public.

War, defeat, the end of the brilliant Second Empire, did not assist artists in finding their way to success. The Bohemian life, precarious before it, was doubly so after, and for many years. As late as 1877 Renoir found himself one day with only three francs (and the urgent need of forty before noon). In the same year he remarked to Théodore Duret (the historian of Impressionism) that he was in a fathomless mess ('un pétrin insondable'). It was in this decade that the pre-war group of friends, resuming their co-

operation, were labelled 'Impressionists', thereby having to contend not merely with neglect but with an active hostility, as merciless as that which had previously assailed Manet.

At about the same time Renoir discovered, or rediscovered, Delacroix, paying his tribute to the sumptuous effect of Delacroix's *Women of Algiers* (which he was always to speak of as one of the supreme masterpieces) in a sort of free 'variation' — a painting (1870) of a Parisienne dressed as an Algerian (Plate 8). It would be fair to say that the pictures produced between 1871 and 1873 are very interesting and unequal. It took some time to pick up the threads. The 'influences' that can be separated out were valuable to his development but still to some extent hid his personality from view. By 1874 the process of assimilation was complete. Renoir the independent and individual genius emerged about the same time as the first Impressionist exhibition was held.

The question has sometimes been asked whether Renoir was really an Impressionist. Ultimately he came to adopt a standpoint very different from that of Monet, and to question many of the tenets by which Impressionism is commonly represented; yet the closeness of his association with the movement is beyond question. He contributed, with Monet, Pissarro, Sisley, Cézanne, Degas and others, to the famous show at Nadar's gallery. When, as a result, a facetious journalist, noting several pictures entitled 'Impression', including an *Impression of Sunrise* by Monet, labelled the group 'Impressionists', Renoir obviously shared the nickname with the rest. He continued to show his pictures at the exhibitions specifically called, unlike the first, Impressionist. Later he spoke of having in 1874 'founded' — with Pissarro, Monet and Degas in particular — the Salon of the Impressionists.

It would, of course, be absurd to assume that the word made them identical. Renoir was never so 'impressionist' as Monet in trying to render truthfully the appearance of objects under a given effect of light at a given time of day; or as Pissarro in cultivating the division of the spectrum colours as a method. Painting was not only scientific observation. The purpose of a picture, he once remarked, was to decorate a wall, which made it important that colours should be pleasurable in themselves and in their relation to one another apart from other considerations.

The idea of an entirely new method aroused the suspicion of one who had practised a traditional craft. It was said, when Impressionism had become a subject of analysis, that it meant ridding the palette of black, an idea of which Renoir did not approve at all. Black had its own value when properly used as the great artists of the past well knew.

Certainly his first great picture, '*La Loge*' (Plate 16), one of the

exhibits at Nadar's in 1874, can be appreciated without much reference to the stock literary terms of Impressionism. It was not an impression of an actual theatre, but was 'made up' in the old studio fashion, a model known as 'Nini gueule de raie' posing for the woman and Renoir's brother for the man. The colour, rich as it is, depends on a contrast (in itself conventional) of warm tones and cool. The artist gives a brilliant demonstration of the depth and vividness of a black which is dominant in the scheme. The people are not seen through an atmospheric veil but stand out clearly as living human beings: in the eyes of Nini there is that extraordinary animation of which Renoir had the secret. There is even a sense of 'period' in the picture, of something not quite contemporary, as if it were a sumptuous pendant to the now historic luxury of the Second Empire.

Henceforward it would seem that Renoir could hardly go wrong. His work now had an unmistakable style. It appears in a succession of beautiful pictures of women and children, possessing that peculiar charm only he could give. *The Dancer* (Plate 15), also exhibited at Nadar's gallery in 1874, has it to the full. For a moment only it recalls the ballet dancers of Degas, yet it has none of the illusionary footlight glamour that balances the latter's sharply critical sense of reality, it is a delicate and tender portrait. He paints an admirable series of nudes, delighting in the pearly and luminous quality of surface; scenes of Parisian life that give us not merely the fact but the sensation; landscapes that vibrate with triumphant colour.

He was Impressionist (as the word is now used) partly in subject, in the keen appreciation of the present, and transient, moment; partly in the great release of colour which was a means of seeing the world afresh. It was inevitable that his work should bear some family likeness to that of the other artists with whom he was associated, not merely as an exhibitor in a gallery but in a more personal fashion. The café and its discussions, however much the frequenters might argue and differ, made for a certain unity. There was a new meeting place in these days, the Café de la Nouvelle Athènes in the Place Pigalle, which had replaced the Café Guerbois in favour since the war. If Renoir was usually quiet, idly tracing scrawls on the table with a burnt match, he was in the current of an idea. Even Manet, enthroned among the artists, receiving the homage of critics and poets, so distinct an individual and of an older generation, having incited a movement became in a sense its follower. In colour and subject he tended to align himself with the younger school. The Impressionist spirit creates its affinity, between Manet's *At the Café* (Fig. 26) and Renoir's (Plate 29); the *Bar at the Folies-Bergère* by the one, the *Moulin de la Galette* by the other (Plate 26).

The habit of painting together retained its importance. With Claude Monet, back from his wartime visits to Holland and (with Camille Pissarro) to London, Renoir once more repaired to the Seine. In a boat moored at Argenteuil they worked as in earlier days side by side, and in that beautiful picture *The Skiff*, Renoir achieves a translation of light into colour as complete as that at which Monet was aiming (Plate 33). It is a curious sidelight on the prejudices from which great artists are not immune, that Manet, who joined them at Argenteuil in 1874, expressed the opinion that Renoir ought to give up painting. The modern observer on the contrary is struck by the mastery Renoir shows in the Impressionist years: the immense skill with which he places a figure in focus in '*La Première Sortie*' (Plate 30; 1876/7), and surrounds it with blurred details to create an 'impression': the resource and variety with which he explores the clarified range of colour, as in the exquisite harmonies of his *Girl with a Watering-Can* (Plate 27; 1876), or the wonderful radiance of the *Girl Reading a Book* of the same year (Plate 20).

There is in the pictures of this productive decade an element of autobiography. His continued friendship with Monet is signalized by the portrait of 1872 (Plate 10), the pictures at Argenteuil. In Paris he had a studio in the rue Saint-Georges. We peep into it in the painting of 1876 (Plate 21) to see some of his friends, the circle that Georges Rivière, one of the champions of Impressionism, has described: the elegant Lestringuez on the left, a civil servant in the French Home Office; in the centre, Rivière himself with drooping lock of hair, elbow on knee; the dreamy musician Cabaner, a young painter called Cordey; and behind Cordey, the already patriarchal-looking head of Camille Pissarro (Renoir's senior by eleven years).

It was then or about then and perhaps in the company of one or other of his callers that he sallied out to look at Paris. He was fond of Montmartre and especially of the Moulin de la Galette, the popular dance hall of the working-class families of the district. As Montmartre was not yet overrun with tourists, the Moulin (which dated from the eighteenth century) had kept an old and rustic flavour. There were two dance floors, one inside and one in the garden or courtyard planted with acacias and furnished with tables and benches. Here Renoir would sit of a summer's evening watching the family parties, and the young men and girls drinking wine or beer and eating the *galette* or pancake which gave the place its name. They danced for the love of it, with happy abandon. Renoir was perfectly at home. It was the people's Paris he had known from his earliest years. It had youth and gaiety: indeed, in spite of its proletarian aspect, it nostalgically recalled the fêtes of the Ancien

Régime. It was the material for a masterpiece of which there are two versions, one painted in the open air and on the spot (in the Whitney collection), the other (Louvre) not materially different in grouping, but more finished, and elaborated in the studio (Plate 26).

The picture was shown in the second Impressionist exhibition of 1876 at the gallery of Paul Durand-Ruel, who had for some time been the staunch supporter of the group. He had shown the work of Monet and Pissarro in London (one of Renoir's pictures *The Pont des Arts* (Plate 4) was exhibited there by him in 1871); further examples in Paris; and risked his professional standing by the venture. The critics of the Parisian press were angrier than in 1874 when Louis Leroy had his little joke about 'Impressionists' in *Le Charivari*, and Renoir, who contributed fourteen works, came in for his share of their fury. They were the cream of his production, including besides the *Moulin*, '*La Première Sortie*', *Girl Reading a Book* and a remarkable nude study of *Anna*. Yet Albert Wolff, the critic of the *Figaro*, whose air of a dilettante Mephistopheles has been respectfully portrayed by Bastien-Lepage, observed: 'Try to explain to M. Renoir that the body of a woman is not a mass of decomposing flesh, with the green and purple spots that denote the entire putrefaction of a corpse.' (Fig. 4).

The exhibitions were a dead loss. So too was the sale at the Hôtel Drouot in the year between, 1875, to which Renoir sent fifteen canvases. It did not bring in enough to pay the auction expenses. Yet a circle of admirers and supporters was beginning to form. It was on the eve of the sale that Renoir met Victor Chocquet, a minor civil servant of very modest means but excellent taste, who had a passion for Delacroix and perceived in Renoir something of that master's quality. Chocquet commissioned him to paint his wife's portrait and then his own (Plate 23 and Fig. 21).

The continued interest of Chocquet in Renoir and Cézanne resulted in many more purchases. When his collection was dispersed in 1899 he had twenty-one pictures by Cézanne and eleven by Renoir. Renoir, however, was able to ascend into regions from which Cézanne, if he had been admitted, would probably have fled at the earliest opportunity, the upper bourgeoisie of the 1870s, wealthy, cultured in its own fashion, but not in general sympathetic to adventures in visual art. The Charpentiers, whom Renoir came to know, were, it is true, of special distinction. Georges Charpentier was the publisher who championed the literary 'naturalism' of the time. His wife had a *salon* frequented by many famous men of letters. Zola, Maupassant, Flaubert, Huysmans, Mallarmé, Edmond de Goncourt ... the list of guests becomes an outline of literature under the new Republic. Painting

Fig. 4
Nude in the Sun

OIL ON CANVAS, 80 × 64 CM. 1875. PARIS,
LOUVRE (JEU DE PAUME)

15

however was sometimes represented by those of a conventional stamp, like the 'idealist' Henner or the conventionally flattering Carolus-Duran, purveyors of the typical 'rich man's art' which Renoir despised. One may wonder at the presence of this man of the people, comparatively unlettered, a Bohemian painter of Montmartre, among them. It would seem that he and Georges Charpentier had met casually at La Grenouillère. The purchase of one of Renoir's pictures at the sale of 1875 led more specifically to an invitation. It is not to be supposed that Renoir found any special attraction in the *salon* as such. He had a distrust of literature as a bad influence on painting and his views of authors were seldom appreciative. He liked to hear Mallarmé talk but had only a glimmering through him of the sensuous power of words. Renoir was not an intellectual. The household of the Charpentiers, in effect, represented for him, not 'culture' but a series of commissions, important not only as leading to a period of comparative success but as marking a climax in his career.

Having painted Madame Charpentier's mother-in-law and her little daughter, Georgette, he produced that excellent portrait of Madame Charpentier herself from which indeed one sees how misleading words can be in visual description. She is spoken of as small and plump: but how little this conveys the handsome presence in the Louvre portrait (Plate 31), the superb textures and that sheer pleasure in the presence of a woman which it was Renoir's peculiar genius to express. The crown of the series was the large 'conversation piece' (in the Metropolitan Museum, New York) of Madame Charpentier and her children (Fig. 27); that handsome composition which takes us into the home of the 'haute bourgeoisie'. A faint tinge of doubt may obtrude itself into one's admiration. There is perhaps a strain of formality in the arrangement of the family group. The artist, as well as the sitters, is on best behaviour. There is a suggestion of 'prettiness' in detail as distinct from his sense of charm: yet it is a work of consummate skill. It is, however, in the portrait of the friend of Madame Charpentier, encountered in her *salon*, the actress Jeanne Samary (whom he painted several times) that he attains a greater height. His delight in her beauty — 'what a skin', he said, 'she positively lit up her surroundings' — is manifest. All the resources of his technique were lavished on the warm and glowing colour. Both the half- and full-length portraits, so alive and spontaneous, are masterpieces of their kind.

The favour of Madame Charpentier was undoubtedly a help to Renoir. She knew several members of the Salon jury and, whether this had influence or no, she was in any case a celebrity — the picture of herself and family was very well placed in the Salon of

1879. There was a surge of interest in his art. Whatever the critics might say about his colour, it was evident that he could paint children in a way that brought out all the appeal of childhood; what a shy attraction had his Mlle Jeanne Durand-Ruel, how plump and rosy was his Mlle Georgette Charpentier. One could not fail to appreciate that he liked to make the best of his models, though not to flatter but rather because this was how he looked at people, with a whole-hearted pleasure, in which there was no concealed element of criticism. The collector Deudon, who bought the *Dancer*, recommended Renoir to his friends the Bérards, a family well known in the diplomatic and banking worlds, and the result was a further series of distinguished portraits.

It might seem that the developments of the later 1870s were urging Renoir into the career of society portrait-painter. He had received 1,000 francs for the Charpentier group, a moderate enough sum but large from an Impressionist's point of view. One commission was leading to more. The situation had its dangers; society portraiture could lure an artist into facile mannerisms, prevent his free expression; but these threats were soon to be left behind in a process of personal development, still a long way from its end.

It was after the Salon of 1879 that Renoir began for the first time to travel. He was thirty-eight. Economic pressure was relaxing. His time had been spent, so far, almost entirely in Paris and the valley of the Seine and he wished to see something of the world. His health was not very good and for a long period he had worked extremely hard and without pause. These were reasons for taking a holiday: but in several ways as he approached the age of forty he seemed to feel he was entering a new phase of life, calling for a pause, break or re-adjustment. It was not too soon to think of getting married — in 1881 he was married to young Mlle Aline Charigot, who had posed for him more than once. It was the right moment also to take stock of his work and to consider where the Impressionist ideas might eventually lead.

His first journey was to the Normandy coast, as the guest of the Bérards, whose château at Wargemont was near the sea. The sea was not really his element and he could not find the same satisfaction as Monet in cliffs and waves, though in his study *The Cliffs of Pourville* (1879; Fig. 5) he gives a spacious feeling of height and distance, governed however by the human scale in the foreground figure of a man.

In 1880 he stayed the summer at Croissy with old friends, the restaurant-keepers Fournaise, of whom he had formerly made two masterly portraits; but the need for more definite change, and, it may well be, the example of Delacroix, who had found a visit to

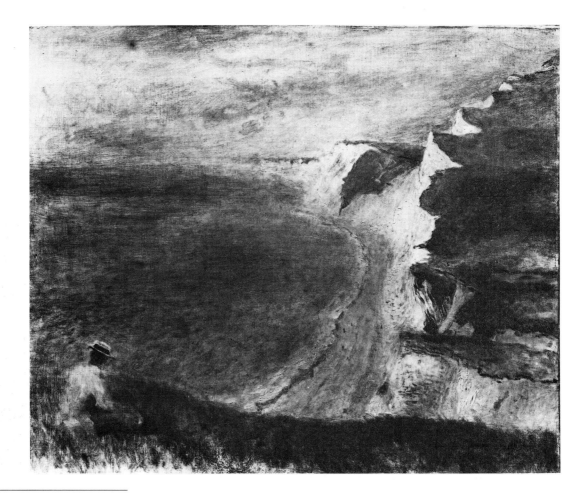

Algiers so rewarding, caused him to go there in company with Lestringuez. It was, he wrote to Madame Charpentier, 'an admirable country', though he struck a rainy season and came back after a few weeks with no very pronounced impressions. A subsequent visit to Algiers accounts for some figure studies in which there is a fragrance reminiscent of Delacroix. At the same time, one notes how little the artist could accommodate himself to the exotic: the face, for example, of the *Algerian Woman* (1881-2) is a type, with wide-set eyes, small nose, and of full oval shape, that appears often enough in his work to be called his own. After his marriage in 1881 he went to Italy, to Florence, Venice, Rome and Naples. It is plain that he was happier at home in France. 'Do you wish to know what I have seen?' he asked in a letter to Madame Charpentier. 'Take a boat and go to the quai des Orfèvres, or opposite the Tuileries and there's Venice. For Veronese, go to the Louvre ...' It was, no doubt, the kind of humour that inexperienced travellers indulge in when writing home. He was in fact impressed by Car-

paccio, 'one of the first who dared to paint people walking in the street' — a comment which makes one think of Renoir's *Place Pigalle*. He was delighted with St Mark's: but the Renaissance churches of Italy depressed him; so did the 'lace-work' of Milan Cathedral; in Rome he was cheered only by the frescoes of Raphael and in Naples by the discovery of the paintings of the ancient world.

Renoir's idea of a holiday was to continue painting and study in museums. The principal landmarks of his journeys are the figure-study (the *Blonde Bather*) painted at Naples, and of Wagner, whose portrait he painted at Palermo in a twenty-five minutes sitting (Fig. 6), the brilliant oil-sketch (of which later he made a replica) making the great composer look (not to his dissatisfaction) like a Lutheran pastor.

The unease of this period seems due, if not to a discontent with his own work, to a feeling that he had gone as far as it was possible for him to go in the study of surface appearance in nature, and in that interchange of light and colour which had become the Impressionist method. The time he spent in the museums increased his dissatisfaction and brought to the fore all that was conservative in his temperament. He had experienced the thrill of discovery but he did not like the idea of a standard or 'official' technique of Impressionism; nor the idea of a continuous quest for something new. No revolutionary, he refused to take part in an exhibition of 'new' art with Gauguin and Guillaumin on the ground that it savoured of 'politics'.

Returning to the old masters, he was compelled to find serious flaws in Impressionism. He reflected that those Greco-Roman artists of Pompeii were happy in having only ochres and browns on their palette (which was decidedly a heresy against the faith of Monet and Pissarro in the pure colours of the spectrum). Black, so often decried, was, as Tintoretto had observed, the 'Queen of Colours' and he knew from his own practice how deft touches of black added to the general brilliance of a colour scheme. There was a dubious theory, held by some critics, that Watteau had foreseen the method of Monet in 'the division of tonalities by touches of colour juxtaposed, reconstituting, at a distance from the eye, the true appearance of the object'. Renoir answered that *Embarking for Cythera* would reveal only mixed tones even if you took a magnifying glass. He had, moreover, serious doubts about painting in the open air: you could not compose, nor could you see exactly what you were doing. Therefore you went back to the studio and in the studio you pursued precisely the same handicraft as the painters of the past with rules that did not change. His discovery in 1883 of Cennino Cennini's *Treatise on Painting* (for which in 1911 he wrote a preface) confirmed him in the belief that a fourteenth-

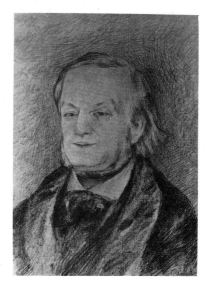

Fig. 6
Portrait of Wagner

DRAWING, 52 × 45 CM. 1882. PARIS, LOUVRE

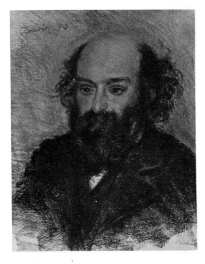

Fig. 7
Paul Cézanne

PASTEL, 54 × 43 CM. 1880. COLLECTION OF
THE ART INSTITUTE OF CHICAGO

century fresco painter had as much of value to impart as any modern. Perhaps, also, his stay at L'Estaque, about this time, with Cézanne (Fig. 7), for whom he had a great admiration as a truly independent spirit among the Impressionists, confirmed him in the need, so much stressed by Cézanne, of referring constantly to the 'musée', of building upon the classic tradition.

For Renoir, this meant the Latin tradition: Velázquez and Goya; the Venetians, Titian, Veronese; the great painters of France. Dutifully (but not warmly) admitting the greatness of Rembrandt, and allowing a wonderful exception in Vermeer, he thought Dutch and Flemish painting tedious and allowed no merit whatever to the English school.

The Luncheon of the Boating Party of 1881 (Plate 36) may be said to mark the end of a period in his art. In his representation of the open-air scene he knew so well, he showed all the skill so wonderfully displayed in the *Moulin de la Galette*. The delightful glimpse of landscape, the sparkling still-life on the festive table, the varied poses of the boaters, the haunting sense of the old 'fête champêtre', again arouse admiration. It would be hypercritical to advance as an objection that it does not add a fresh pleasure to that we have previously enjoyed: yet Renoir felt he was in danger of becoming static. He began to discard richness of incident and open-air effect in favour of simpler and well-defined form. A new precision of outline appears in the *Blonde Bather* of 1881. There is a tendency towards it in the series of paintings of dancing couples, of which the *Dance at Bougival* (Plate 38; 1883) is an example. A new insistence on formal or decorative elements of design, together with an enamel-like smoothness of surface that recalls the technique of Boucher (a little, also, that of the porcelain workshop) shows itself in *The Umbrellas* (1881-6; Plate 39). There is a great difference from the earlier pictures of the Parisian scene such as *Leaving the Conservatoire*, where the design makes itself, so to speak; in *The Umbrellas* (which can now be seen in the National Gallery in London) the formal pattern is artificially imposed to unify the moving crowd. There is a certain loss of the old spontaneous feeling, of the pulse of real life; to offset this, a decorative gain.

What was the 'classicism' to which the uncertainties and discontents of 1881 to 1883 (or thereabouts) eventually led? The representation of the human figure; the beauty not of transient effect but of form in a durable sense that allied it with sculpture; the choice of such elements as were timeless — for example a grove (but not a garden, the plan of which assigned it to a place or period), a piece of drapery (but not a period dress). These were eighteenth-century canons, such as the English student finds in Sir

Fig. 8
Study for 'The Bathers'

DRAWING, 1.06 × 1.59 CM. C.1884 PARIS,
LOUVRE (CABINET DES DESSINS)

Joshua Reynolds's *Discourses*. In following them, Renoir placed a distance between himself and the convinced Impressionist — a Monet or Sisley, to whom the figure was of minor importance, who painted a landscape that was certainly of the nineteenth century, who was so much less interested in the sculptural form than the effect of light. The classical canons had their triumph in the great work which occupied Renoir for several years, *The Bathers* (Plate 40). Little concerned now with 'contemporanéité', Renoir openly borrowed from a bas-relief at Versailles of bathers by the seventeenth-century sculptor, François Girardon. The result was a picture of great beauty but divorced from time and place, with some of the sculptural quality of relief, while the nymphs bathe in the shade of trees whose foliage is no longer tremulous with light but dry and hard like that of a follower of Giotto (Fig. 8).

It was the beginning of what is known as his 'manière aigre', his 'dry' period, though Renoir was too much of an 'irregularist' — to borrow the word he invented for a possible society of artists — to be entirely consistent or uniform.

On the other hand, he is aware of the intimate aspect of life afforded by marriage. In 1886 his first son Pierre was born. In his new linear manner and yet with appreciation of the buxom appearance of Madame Renoir, with her baby at her breast, he painted the beautiful *Mother and Child* of 1886. Charm returns, here and in the *Washerwoman and Child* of 1886. It was not always easy to disengage real life from his classic aims, or alternatively to combine them with entire success. One is conscious of the effort in the somewhat metallic effect of the *At the Piano* (Plate 42), as com-

pared, let us say, with the *Daughters of Cahen d'Anvers*, of eight years before.

One sees Renoir in middle age, settling down in his home circle and in French country retreats, painting with an exclusive and unremitting industry. He rounded off his knowledge of the world outside France with a visit to Spain where he found no pretty women and a 'total absence of vegetation', being consoled only by Velázquez (all the art of painting, he said, was in the pink ribbon worn by the Infanta Margarita); and Goya — his *Royal Family* alone was worth a visit to Madrid. He went to Holland, with no great excitement: and his short visits to England provoked only those disparaging reflections on Turner and an enthusiastic comment on the National Gallery's Claude Lorraines. In 1892 he went to Pont-Aven in Brittany, where he conceived great contempt for the 'international school of painting' as represented by Gauguin, his friend Emile Bernard and their entourage; not to speak of the seaside air which he blamed for increasing twinges of rheumatism.

In 1898 he bought a house at Essoyes in Burgundy, where he spent the summers with his family, but the creeping advance of arthritis caused him to seek the warm climate of the south at Cagnes, where he regularly spent the winter from 1903 onwards.

The settled domestic life had its influence on his art, at least as far as the choice of subject was concerned. Madame Renoir was constantly before his eyes to remind him with her own splendid proportions that a woman should be painted 'like a beautiful fruit'. His second son Jean was born in 1893, his third son Claude, nicknamed 'Coco', in 1901. They inspired more of those paintings of childhood in which he had always excelled: though his study of the little human group of which he was the head was more intimate than the commissioned portraits of earlier days, with an observation of everyday attitude and expression that is beautifully seen in the *Reading Lesson* and the *Writing Lesson*. The family progress through the years is commemorated in the *Mother and Child* of 1886; the picture of Jean Renoir and the servant Gabrielle (who so often served him as model — see Plate 47) and her little girl, in the early 1890s; the *Artist's Family* of 1896, with its, perhaps deliberate, emulation of the opulent manner of Rubens; Pierre, growing up, in 1898; Jean Renoir, in the white pierrot dress of Watteau's Gilles, in 1906; Madame Renoir, mature and benevolent-looking in 1910.

The picture dealer, Ambroise Vollard, whom Renoir first met in 1894 (and painted several times — see Plate 44), and who subsequently became a familiar of the household, has given a pleasant evocation of its life, which ran with unobtrusive smoothness. There was an air of prosperity. Since 1886 when the Impressionist

Exhibition in New York took America by storm and created a constant demand for Impressionist pictures, Renoir like his confrères and their loyal supporter Durand-Ruel, had been well out of the financial wood. Madame Renoir arranged things. She did not complain when the two servants Gabrielle and La Boulangère were requisitioned for a study of bathers. Under her supervision the bouillabaisse tasted better than elsewhere, though Renoir himself demanded of the cook only that her skin should 'take the light well'. She arranged, without his knowing how carefully, those vases of flowers which, to her delight, he sometimes painted. She thought of all the details at once: looking after the children, shelling peas, going to Mass, cleaning her husband's brushes — 'he finds', she said, 'I clean them better than Gabrielle.'

Insensibly, one century gave way to another; in due course, and inevitably with a grumble at mechanical progress, Renoir had his automobile, though in a way his existence had become timeless. The intimate idyll was contained within a larger one, that of Provence itself. Provence where he was finally settled was the Hellas of France, the setting of a golden age. The olive trees on the estate of 'Les Collettes', his house at Cagnes from 1903 onwards, were reputed to be a thousand years old. In this landscape, with its blue and purple mountains in the distance, its grey olives, its slight vibration in the air that told of the nearness of the land-locked sea, its pervading warmth of colour, the nude figure could be placed in its proper context, its own country.

In his method of painting he came back to that transparency from which he had first been diverted by Courbet: a method approaching that of watercolour, a medium which, like Cézanne, he used occasionally with exceptional understanding. During his Impressionist days he applied transparent colour to reinforce the opaque substance of oil paint, in accents and surface touches — but from about 1890, he evolved his picture from transparent glazes through which the white canvas still appears.

It was in 1889, when he was forty-eight, that Renoir first endured those severe attacks of arthritis which made the later years of his life a physical martyrdom. He tried various cures, courses of massage and baths, saw, as he told Julie Manet, a lot of people come limping to Bourbonne-les-Bains and go away cured, but came to the conclusion that his own case was hopeless. 'Je suis pincé, ça va lentement mais sûrement.' He had operations on his knee, foot and hand. For several years he was able to get about with crutches, but at last in 1910 he was confined to a wheeled chair. In 1912 he was for a time completely paralysed. 'My husband', wrote Madame Renoir to Durand-Ruel from Cagnes, 'is beginning to move his arms though his legs are still the same. He can't stand

upright, though he's getting used to being immobile. It is heart-breaking to see him in this state.'

Yet the man, helpless in his old age, with poor twisted joints, his thin, sparsely bearded face puckered with pain, still had his humour and his will to create. He could think of himself as a *veinard*, a lucky chap, because he was able to paint in his chair. Sometimes he would grow fretful, and speak of giving up. Then the next morning, a fresh young model would arrive from Nice and he was happy again. Before ten he was at his easel in the garden studio, looking over the previous day's work, noting with satisfaction the quality of warm light in a landscape, or on youthful limbs. 'It's a pity', he remarked, 'they won't be able to say I painted surrounded by nymphs and crowned with roses or with a pretty girl on my knees like the Raphael of Ingres.' The brush was affixed with sticking plaster to his crumpled hand — he called it 'putting on his thumb'. Once in position it was obviously not practicable to change brushes at intervals. He used the same brush throughout, dipping it in turpentine at intervals to clean it. The brush stroke was fumbling yet this did not weaken the power of the vision he transferred to canvas, which seemed even to gain, in youth and energy, as it grew more difficult for him to work.

In these years he made his experiments in sculpture. One is inclined to think of Renoir solely as painter and colourist, yet he could dispense with colour and had tried other media. While still able to use his hand freely, he made a few etched plates, the first a soft-ground etching for the *Pages* of Mallarmé, published in 1891. A more congenial experiment was lithography, and about 1904 he made a number of lithographic prints in which he found himself well able, with the soft chalk, to 'model' a figure without the use of colour. This led on to his essay in actual modelling; his first effort in 1907 being the fine relief of *Coco* (the only sculpture executed by his own hand; Fig. 9). Other medallions, the high-relief of the *Judgement of Paris* and the completely plastic *Venus Victrix* belong to the period of immobility. He could see, he could not model. One thinks of the opposite case of Degas, who called a sculpture a blind man's art, and with blurred vision relied, in producing his wonderful statuettes, on the sense of touch. Renoir on the contrary worked by remote control, directing the hands of two intelligent young craftsmen, by means of a long stick, conjuring up, with this wand, a massive goddess, superbly and in no imitative fashion 'antique'.

The struggle of the crippled man is one of the heroic legends of art. Not only would he not give in, he contemplated fresh triumphs, was able to achieve them. Immersed in his efforts, transported into the timeless world of his bathers, one realizes with a shock of surprise that the clock of history had moved inexorably on

and that war loomed — the First World War.

Renoir in 1914 was seventy-three, Pierre was twenty-nine, Jean twenty-one. The young men went into the army. The old people were left together. Renoir, who remembered well the false optimism of 1870, was sceptical of the flying rumours of quick victory. The 'Russian steam-roller', he was told, would crunch its way to Berlin by October. 'Now', said Renoir, 'I become really uneasy. They are going mad.' Thinking of his sons he flung down his brushes one day. 'I shall paint no more.' Madame Renoir knitting a soldier's scarf sighed and bent over her work.

Pierre and Jean were both wounded. Madame Renoir died in June, 1915. The lonely old artist went on painting and the final phase of these war years is something to marvel at. He pursued his evolution to the end in that final burst of free and entirely personal expression in which some of the greatest painters (Titian and Turner are examples) have found complete fulfilment.

From the wheeled chair he could paint a portrait as well as ever (Fig. 10). There is great verve in the portrait of Madame Galéa painted at Nice in 1912, no less in the brilliant portrait of Vollard in 1917. Few men incidentally can have been portrayed by so many gifted hands in so many different ways. His appearance as a bull-fighter is explained by Renoir's desire to paint the silver and blue costume of the matador. Vollard had it made specially in Spain.

Yet the peak of Renoir's achievement is to be found in his final interpretation of the nude, the last swirl of chromatic delight. He had found a new model, 'Dédé', whom one detects in the roseate bathers with their small firm breasts and long flanks. She has her importance in having incited him to the eager activity that culminates in *The Bathers* of 1918 (Plate 48) with its rosy flush of colour, its expression of form as distinct and masterly as Cézanne's though so different from it. We cease to think of the real world: we enter the world of Renoir's mind, the ultimate vision of timeless beauty.

He died in 1919, aged seventy-eight, after a bout of pneumonia that lasted for a fortnight, murmuring towards the end, 'I begin to show promise.' Of the Impressionists only his old friend Monet, who died in 1926, outlived him. Renoir had 'arrived' as not many painters had in their lifetime. Honours were showered upon him. His studio at Cagnes was a place of pilgrimage. In August 1919 the portrait of Madame Charpentier was among the acquisitions of the Louvre and he was wheeled in his chair through the galleries 'like a pope of painting'.

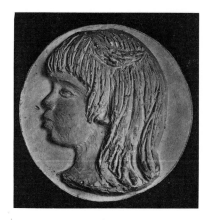

Fig. 9
Claude 'Coco' Renoir

PLASTER RELIEF, DIAMETER 22 CM. C.1907.
PARIS, MUSÉE MARMOTTAN

Outline Biography

1841 Born at Limoges, 25 February, one of five sons of Léonard Renoir, a tailor, and his wife Marguerite.

1844 Family moves to Paris.

1854 Renoir leaves school and is apprenticed to Lévy Brothers, painters of porcelain.

1859 Goes to work for M. Gilbert, painter of blinds used in mission stations.

1860 Begins copying in the Louvre.

1862 Passes the entrance examinations for the École des Beaux-Arts. Attends Charles Gleyre's Academy where he meets Monet, Bazille and Sisley.

1864 Submits a painting to the Salon. It is accepted, but Renoir destroys it after the exhibition closes.

1865 Begins painting in the Forest of Fontainebleau. Two submissions to the Salon are accepted.

1867 *Diana* rejected at the Salon.

1868 *Portrait of Lise* accepted at the Salon.

1870 Exhibits *Bather with a Griffon* and *Odalisque* at the Salon. Serves with the 10th Chasseurs during the Franco-Prussian War.

1872-1874 Meets Paul Durand-Ruel for the first time. The dealer's first purchase is *The Pont des Arts*. Works frequently with Claude Monet at Argenteuil. Is actively involved in the organization of the first Impressionist exhibition in 1874.

1875 Ten of his paintings at an auction at the Hôtel Drouot fetch less than 100 francs each. Meets Georges Charpentier as a result of this auction.

1879 Success at the Salon with *Madame Charpentier and Her Children*. Meets Paul Bérard and frequently visits the Bérards home at Wargemont.

1881 First visit to Algiers. Travels to Italy, visiting Venice, Florence, Rome, Naples, Pompeii and Capri.

1882 Goes to Palermo to paint Wagner's portrait. From Italy goes to visit Cézanne at L'Estaque, where he contracts pneumonia. Second visit to Algiers.

1883 Travels widely in France and visits Jersey. In December, travels with Claude Monet on the Côte d'Azur.

1885 Birth of his first son Pierre.

1888 Visits Cézanne at Aix-en-Provence.

1889 First attacks of arthritis and rheumatism.

1892 *At the Piano* purchased by the French State, Renoir's first official recognition.

1893 Birth of Jean.

1900 Awarded the *Chevalier de la Légion d'honneur*.

1901 Birth of Claude ('Coco').

1902 His health becomes increasingly bad and severe attacks of arthritis and rheumatism gradually cripple him.

1903 Makes his home at 'Les Collettes', Cagnes-sur-mer.

1910 Short visit to Munich to his friends the Thurneyssens.

1915 Death of Aline Renoir.

1919 3 December. Renoir dies at Cagnes.

Fig. 10
Renoir in His Studio

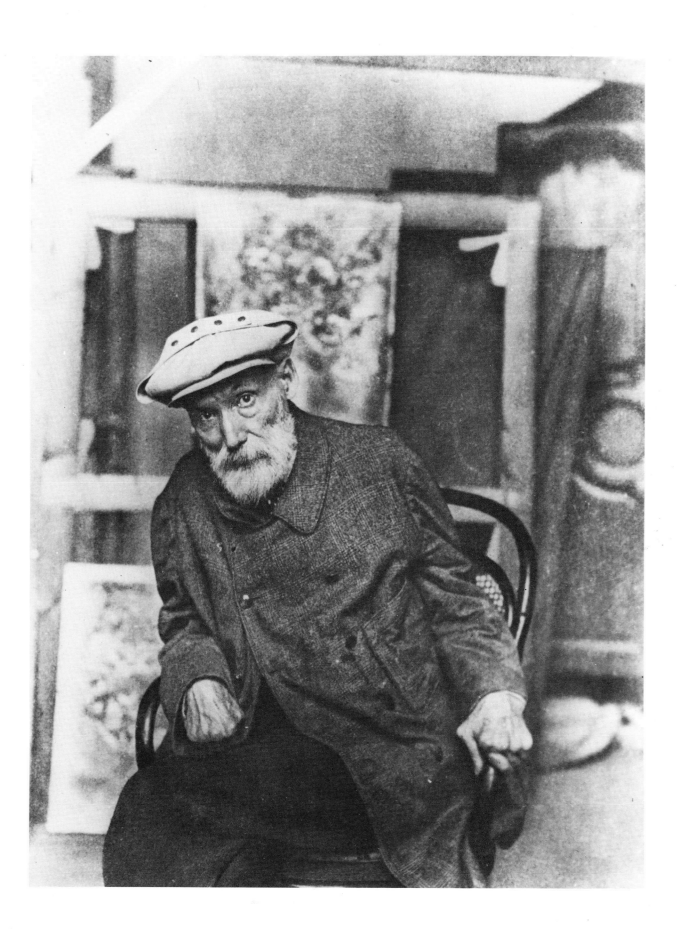

Select Bibliography

CATALOGUES OF RENOIR'S WORK

François Daulte, *Catalogue Raisonné de l'Oeuvre peint*, I Figures 1860-1890, Lausanne, 1971 (first of five projected volumes)
Ambroise Vollard, *Tableaux, Pastels et Dessins de Pierre-Auguste Renoir*, 2 Vols., Paris, 1918
François Daulte, *Renoir*, London, 1973
L. Delteil, *Pissarro, Sisley, Renoir* (Le peintre-graveur illustré, v. XVII), Paris, 1932 (etchings and lithographs)
P. Haesärts, *Renoir Sculpteur*, Belgium, n. d.

MONOGRAPHS

Ambroise Vollard, *La Vie et l'Oeuvre de Pierre-Auguste Renoir*, Paris, 1918
Georges Rivière, *Renoir et ses amis*, Paris, 1921

Walter Pach, *Pierre-Auguste Renoir*, London, 1951
M. Drucker, *Renoir*, Paris, 1955
François Fosca, *Renoir*, London, 1961
Jean Renoir, *Renoir, My Father*, London, 1962
Raymond Cogniat, *Renoir: Nudes*, London, 1964
Pierre Cabanne, *Renoir*, Paris, 1970
Keith Wheldon, *Renoir and His Art*, London, 1975
Anthea Callen, *Renoir*, London, 1978

GENERAL BOOKS

L. Venturi, *Les Archives de l'Impressionnisme*, Paris, 1939 (primarily on Durand-Ruel's relations with the Impressionists)
John Rewald, *The History of Impressionism*, 4th edition, London and New York, 1974 (the standard history of Impressionism, with an extensive bibliography on Renoir)

List of Illustrations

Colour Plates

Text Figures

Comparative Figures

Spring Bouquet

OIL ON CANVAS, 104 × 80.5 CM. 1866. CAMBRIDGE, MASS., FOGG ART MUSEUM

From 1864 until the end of his life Renoir painted flower still-lifes. In them he felt able to resolve problems without the tensions created by the presence of a model. He told Albert André: 'I just let my brain rest when I paint flowers. ... When I am painting flowers, I establish the tones, I study the values carefully, without worrying about losing the picture. I don't dare to do this with a figure piece for fear of ruining it. The experience which I gain in these works, I eventually apply to my [figure] pictures.' In this painting Renoir was beginning to free himself from Courbet's domination, and after attempting several flower paintings with the palette knife, had returned to the use of a heavily loaded brush. The apparent informality of the arrangement of the blooms belies the careful balancing of the entire composition around a central vertical axis.

The profusion of flowers and the sense of abundance created by the full forms of the roses and irises evoke the Dutch masters, and also convey Renoir's sheer pleasure in painting. The delicacy of handling in the treatment of the vase and individual flowers recalls Renoir's youthful experience as a porcelain painter.

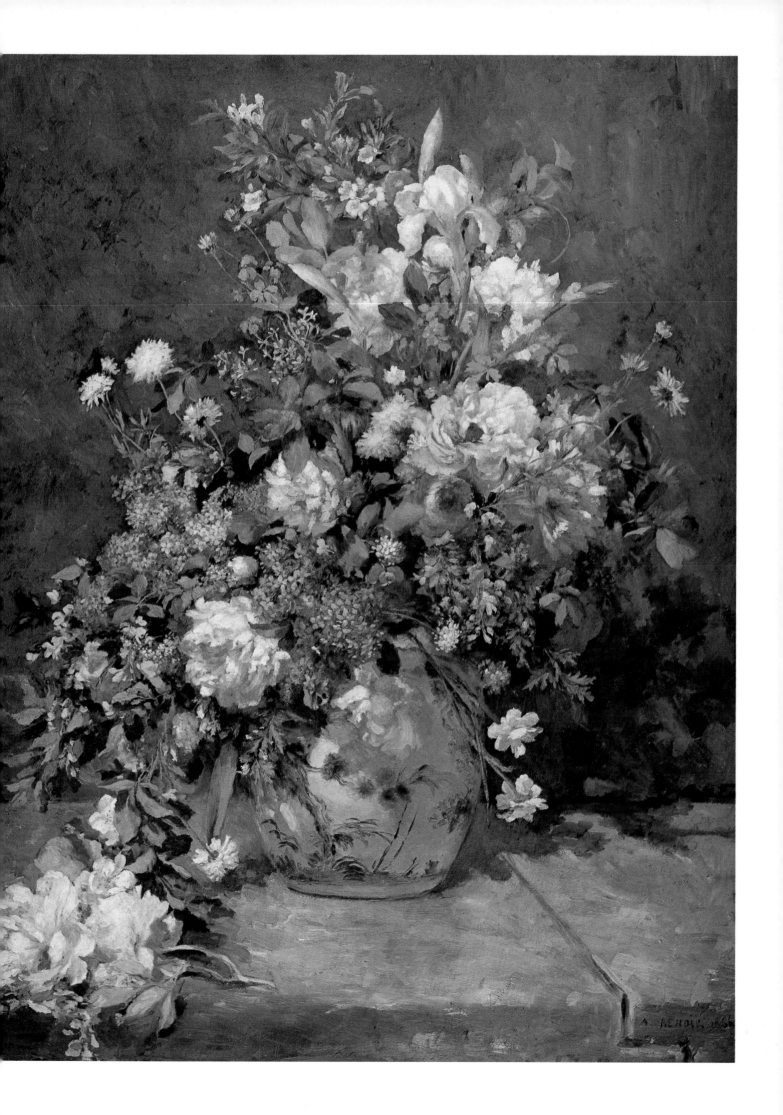

Portrait of Lise

OIL ON CANVAS, 184 × 185 CM. 1867. ESSEN, FOLKWANG MUSEUM

This painting of Lise Tréhot, Renoir's favourite model from 1865 to 1872, was executed at Chailly in the Forest of Fontainebleau and exhibited at the Salon of 1868. It is indebted to Courbet both in the boldness of execution and compositionally, to one of the figures in Courbet's *Village Maidens*, exhibited at his one-man show in 1867. Monet's monumental *Women in the Garden* of 1866-7, rejected at the previous year's Salon, must also have influenced Renoir strongly.

Lise's white dress is set off by a trailing black sash and Renoir studied the play of light and shadow *en plein air*, causing the critic Thoré-Bürger to remark at the time of its Salon hanging: 'The dress of white gauze, enriched at the waist by a black ribbon whose ends reach to the ground, is in full light, but with a slight greenish cast from the reflections of the foliage. The head and neck are held in a delicate half-shadow under the shade of a parasol. The effect is so natural and so true that one might very well find it false, because one is accustomed to nature represented in conventional colours … Does not colour depend upon the enviroment that surrounds it?'

The landscape background is treated imprecisely, serving as a foil to the life-sized figure of Lise.

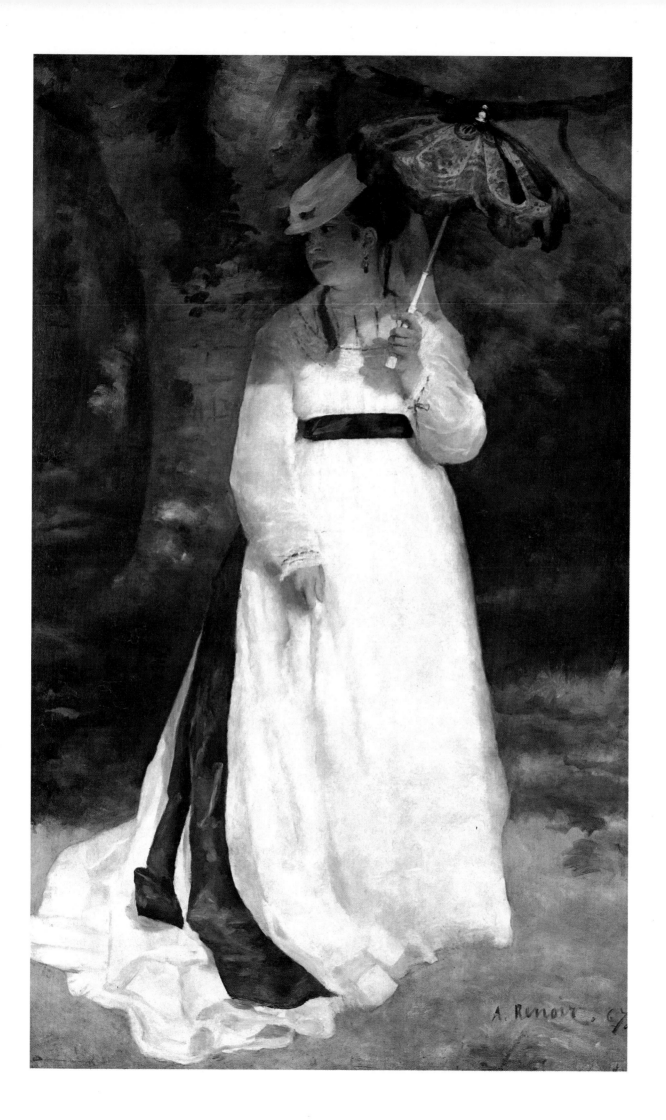

The Painter Bazille in His Studio

OIL ON CANVAS, 106 × 74 CM. 1867. PARIS, LOUVRE (JEU DE PAUME)

Renoir painted this portrait of his friend Frédéric Bazille while he was working in his studio at 20 rue Visconti, Paris. Bazille is shown painting a still-life, his *Still-Life with Heron*, now in the Musée Fabre, Montpellier. Renoir shows him working intently on his painting, using a studio easel called a *chevalet méchanique* or *chevalet anglais*. Renoir's version of Bazille's painting is far looser and freer than the original.

Alfred Sisley must have been present at the same time because he also painted the heron, on a canvas identical in size to that of Bazille but used inverted. The painting on the wall behind Bazille is a snowscape by Monet, *La route de la ferme Saint-Siméon en hiver*.

Edouard Manet admired Renoir's portrait, and it is likely that Renoir presented it to him, although Manet may have purchased it. When Bazille was killed in November 1870, three months after enlisting in the Zouave regiment, his father made an exchange with Manet, giving him Monet's *Women in the Garden* for this portrait. The painting was exhibited at the second Impressionist Exhibition in 1876, and was presented to the Musée du Luxembourg by the Bazille family in 1923.

Bazille's comradeship and financial support was invaluable to Renoir and Monet in the 1860s, and his premature death was a severe loss for them.

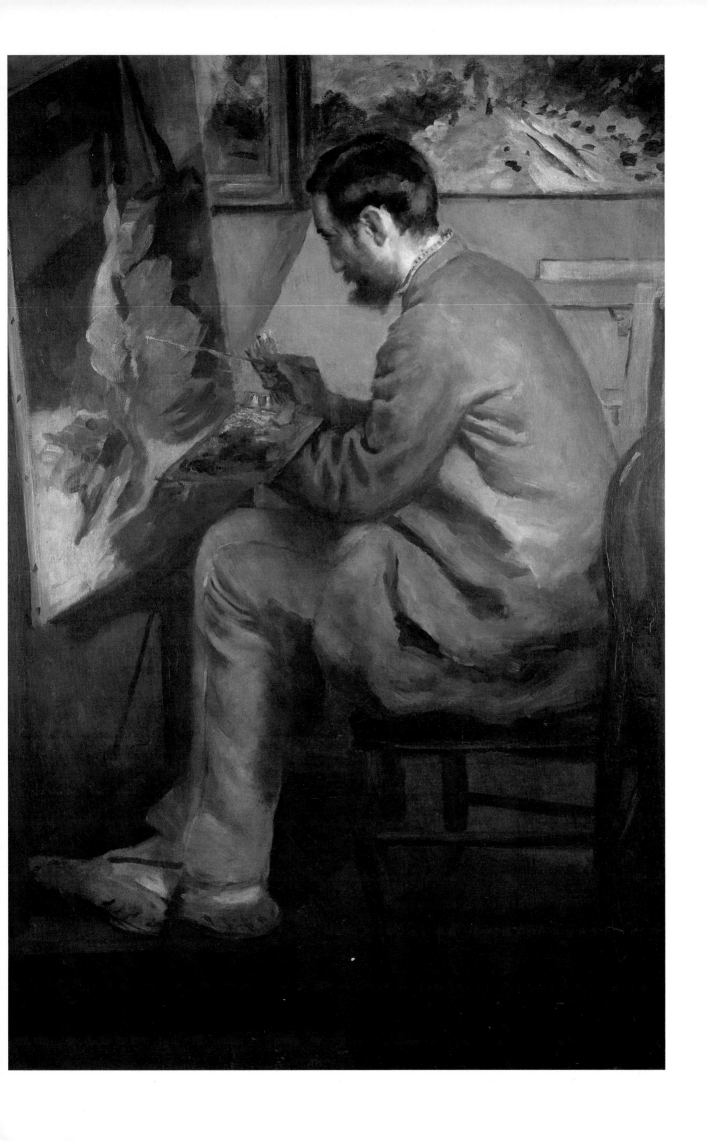

The Pont des Arts

OIL ON CANVAS, 60 × 98 CM. C.1867. LOS ANGELES, THE NORTON SIMON FOUNDATION

Like his friend and close companion Claude Monet, Renoir was attracted to cityscapes in the late 1860s, especially views of contemporary Paris. In this painting he shows the Palais Richelieu and the Institut de France, clearly outlined against the sky, and the Pont des Arts

The foreground area is empty except for the shadows of figures leading the eye to the small-scale cluster of figures in the centre of the painting, who are shown strolling in the sun, queuing to embark on a river trip, or walking across the bridge. Many of these figures were added after the initial layers of paint had dried, indicating that Renoir concentrated on the static element of the scene, the architecture, and added the human element later.

The elongated format of the canvas was selected to emphasize the horizontality of the panorama Renoir depicted. In contrast to Monet's *Garden of the Princess, Paris* (Fig. 11), which employs a high viewpoint, and indeed in contrast to other views of Paris painted at this time and later by Monet, Pissarro and Caillebotte, Renoir preferred a low viewpoint, painting at ground-level rather than from an upper-floor window. This preference for immediacy and directness is a constant feature of his work, and is encapsulated in his painting of the Pont Neuf (Washington D.C., National Gallery of Art), painted five years after this picture. He sat outside a café outlining the architectural elements of the painting and then delegated his brother Edmond to stop passers-by with some question while he rapidly sketched the figures in to the painting.

Fig. 11
CLAUDE MONET
The Garden of the Princess, Paris

OIL ON CANVAS, 91.8 × 61.9 CM. 1866. OHIO, OBERLIN COLLEGE, ALLEN MEMORIAL ART MUSEUM

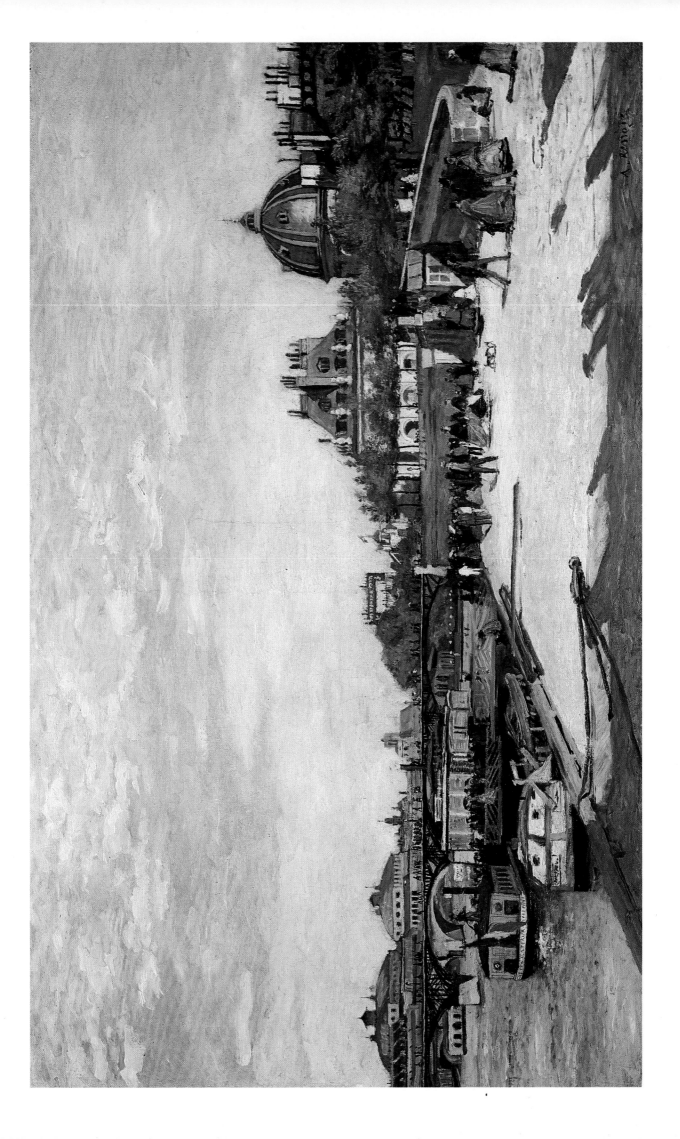

Alfred Sisley and His Wife

OIL ON CANVAS, 105 × 75 CM. 1868. COLOGNE, WALLRAF-RICHARTZ MUSEUM

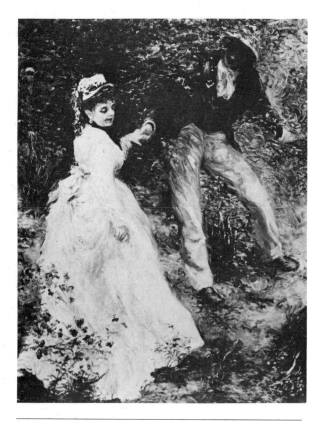

Fig. 12
The Promenade
OIL ON CANVAS, 81 × 65 CM. 1870. PRIVATE COLLECTION

Renoir and Alfred Sisley were close friends after their meeting at Gleyre's atelier in 1862, and Sisley was one of the figures Renoir painted in *At the Inn of Mother Anthony* (Fig. 2), the inn at Marlotte where he and Sisley often enjoyed a meal even when they did not stay there. Renoir's portrait of Sisley's father William was exhibited at the Salon of 1865.

This painting was probably executed at Chailly in the Forest of Fontainebleau in April 1868, but the landscape background is vague and insubstantial and Renoir focuses all his attention on the figures of Sisley and his wife Marie, whom he had married two years previously (see also Fig. 12). Renoir employs rather formal, courtly poses to convey the relationship between the two. He described Marie as having a very sensitive nature and being exceedingly well-bred.

Renoir once said, 'Courbet was still tradition, Manet was a new era in painting.' Here, especially in the relation of Sisley to the background, in the use of the trouser stripe to establish a precisely demarcated division between areas, and in the flattening and reduction of internal modelling in Sisley's body, the influence of Manet is apparent. Manet's *The Fifer* (Paris, Louvre), for example, which was painted in 1866 and which Renoir copied in a drawing, exploits the stripe on the fifer's uniform in a similar manner.

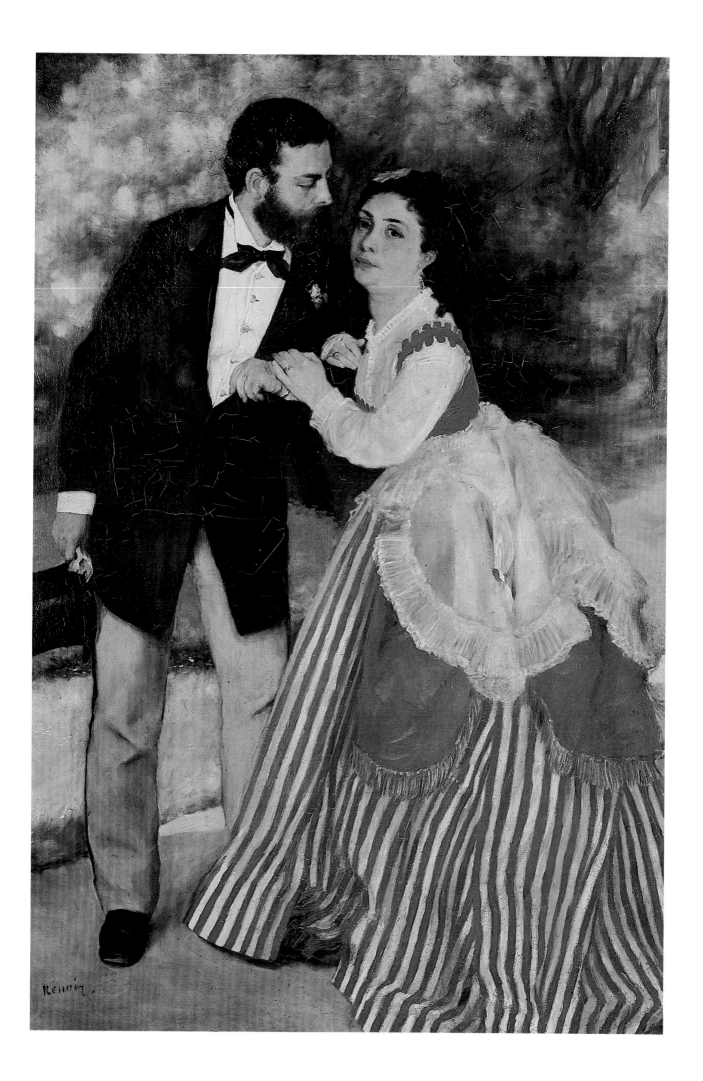

La Grenouillère

OIL ON CANVAS, 66 × 81 CM. 1869. STOCKHOLM, NATIONALMUSEUM

La Grenouillère ('The Frog Pond') was a bathing-place and restaurant on the Seine at Croissy, near Chatou. It was close to Paris and very popular, and Renoir's painting shows the strolling passers-by and the bathers, and captures the gaiety and liveliness of this recreation spot.

The foliage on the river bank is not differentiated as it is in Claude Monet's paintings done at the same time, and the soft greens and yellows Renoir uses in the background serve to accentuate the contrast between the figures and the landscape, and heighten the contrast between the women's flimsy white dresses and the black suits worn by the men.

Changes have been made in the foreground, and the position of the left-hand boat in particular has been adjusted to focus the viewer's attention more directly on the group of figures in the centre of the painting.

In this and other paintings of the same scene (Fig. 13) Renoir seeks to capture the spirit of 'la vie moderne', as advocated by Baudelaire in his review of the Salon of 1846. He paints 'la vie parisienne', 'rich in poetic and marvellous subjects', and also records the effects of sunlight on water and the movement of coloured reflections observed *en plein air*.

Fig. 13
La Grenouillère

OIL ON CANVAS, 59 × 80 CM. 1869. MOSCOW, PUSHKIN MUSEUM

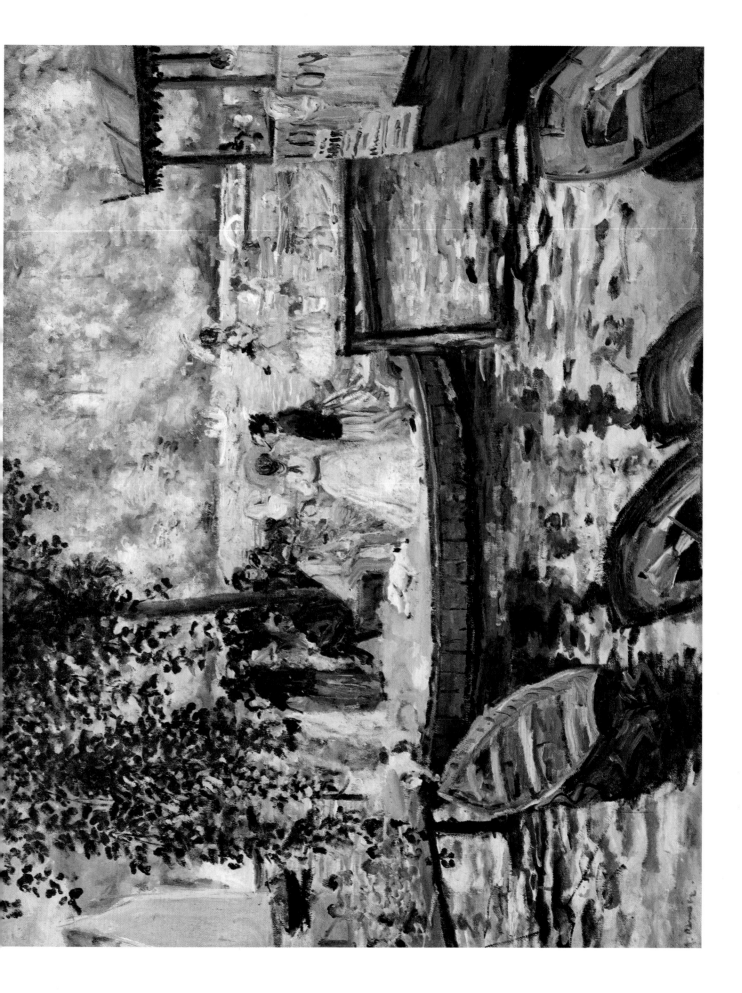

Bather with a Griffon

OIL ON CANVAS, 184 × 115 CM. 1870. SAO PAULO, MUSEU DE ARTE

Renoir exhibited this painting, again using Lise Tréhot as his model, at the Salon of 1870. The painting still owes a considerable debt to Courbet. The nude figure is solid and heavy and Renoir has altered the proportions of Lise's body (compare *La Nymphe à la Source*, Plate 9) to create a Courbetian type. The relationship that is implied between the two women, the one nude, the other clothed and looking round the body of her companion also recalls Courbet (Fig. 14).

The pose of the nude is derived from the Cnidian *Aphrodite*, a *contrapposto* pose with the left hand masking the genitals. The figure is life-size and in accordance with the requirements for Salon ac-ceptance the brushwork is tightly controlled in the treatment of the nude, although it is considerably looser in the description of the fabric of the clothing at her side. The landscape is used as a foil to the figure, with the gap in the trees on the left-hand side of the canvas permitting Renoir to show pink-tinted re-flections in the water. The griffon, a dog of a terrier type, sits alertly, ears pricked, on a pile of garments belonging to its mistress.

The painting is a compromise between Renoir's desire for Salon acceptance (and his recognition of what this entailed), and his interest in observed light and colour with a freer, looser application of pigment.

Fig. 14
GUSTAVE COURBET
Woman with a Parrot

OIL ON CANVAS, 129.5 × 195.6 CM. 1866. NEW YORK, THE METROPOLITAN MUSEUM OF ART,
BEQUEST OF MRS H.O. HAVEMEYER, 1929. THE H.O. HAVEMEYER COLLECTION

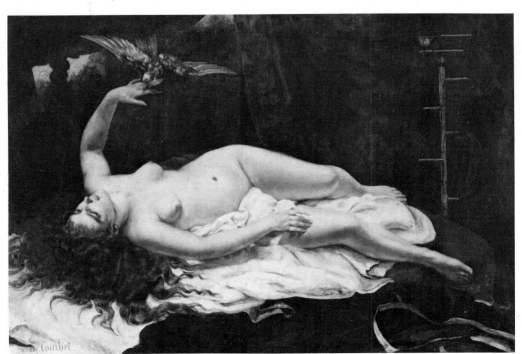

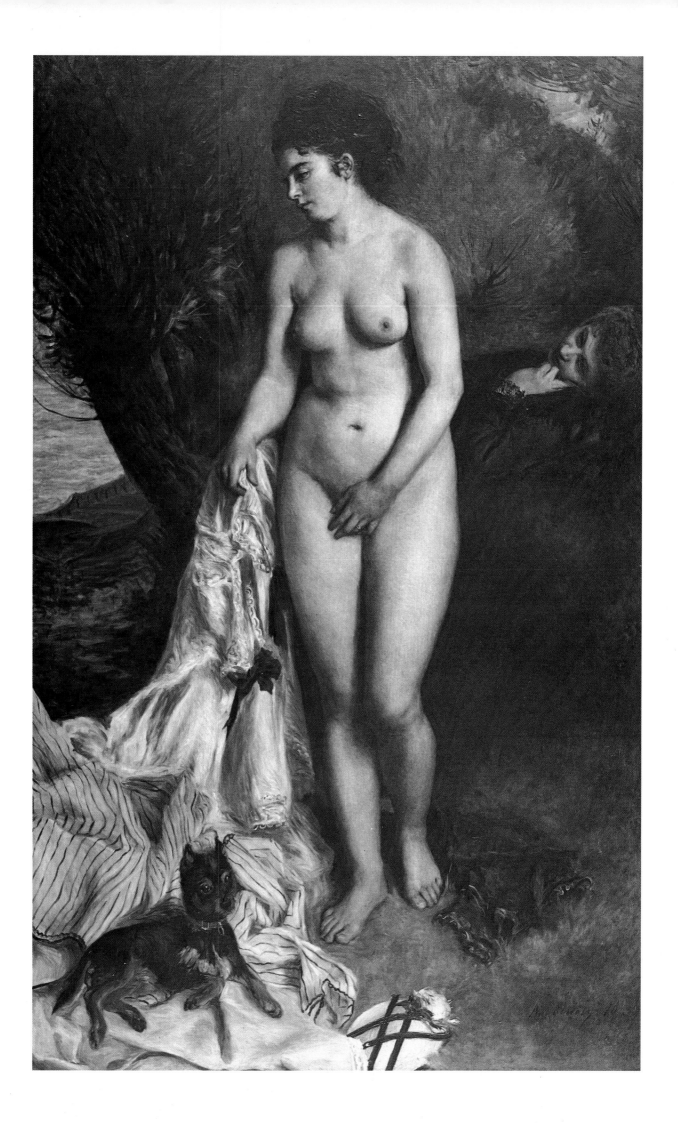

Odalisque or 'La Femme d'Alger'

OIL ON CANVAS, 69 × 122 CM. 1870. WASHINGTON D.C., NATIONAL GALLERY OF ART (CHESTER DALE COLLECTION)

Fig. 15
EUGÈNE DELACROIX
The Women of Algiers

OIL ON CANVAS, 177 × 227 CM. 1834. PARIS, LOUVRE

The model for the painting was Lise Tréhot, dressed in exotic Oriental garb and looking seductively at the spectator. The painting was exhibited at the Salon of 1870. Both in its subject-matter and in its glowing colour it is indebted to Delacroix – to his *Femmes d'Alger* (Fig. 15) in particular. Arsène Houssaye wrote of it, 'One can study the proud, painterly temperament which appears with such brilliance in a *Femme d'Alger* that Delacroix could have signed it!' Renoir admired Delacroix greatly and said of his picture that there was not a more beautiful painting in the world. Later, in the 1870s, he continued his homage to Delacroix by copying his *Jewish Wedding in Morocco*.

Renoir took his place among many French artists paying obeisance to the Oriental tradition with this painting, a fantasy vision of splendour and allure. The richness of colour and the contrasting textures – skin, gold jewellery, brocade and muslin – are a sensual delight. The work is in marked contrast to its more laboured companion at the Salon, *Bather with a Griffon* (Plate 7). However, Renoir's interpretation of the odalisque theme is totally passive and compliant, without the challenge presented by Manet's *Olympia*, which had so enraged spectators five years before, and was acceptable to Salon jury and public alike.

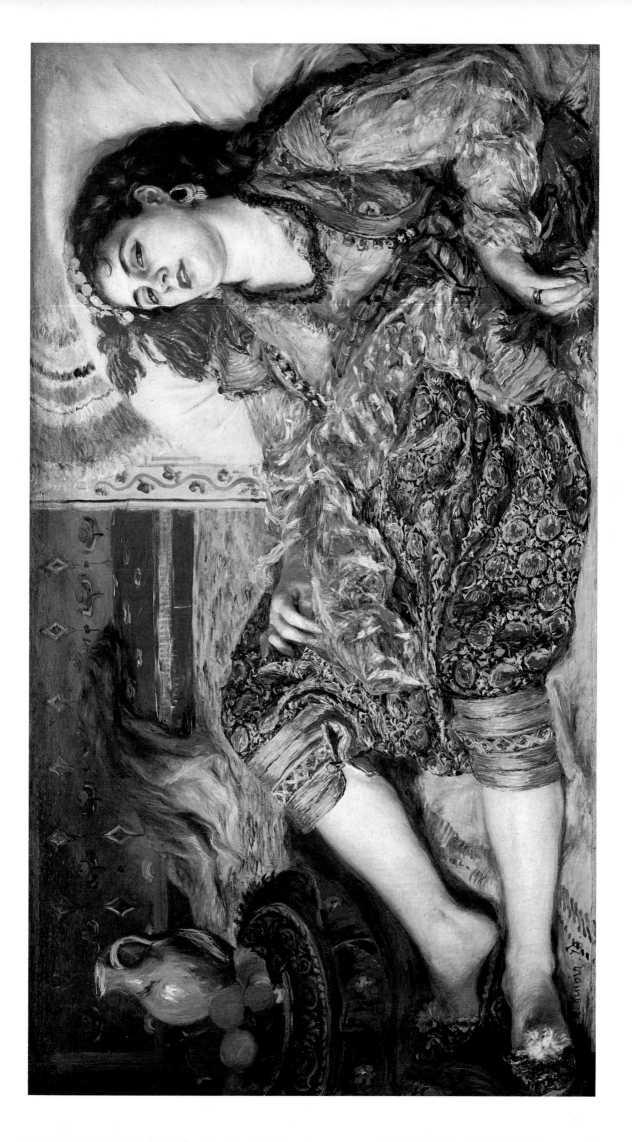

'La Nymphe à la Source'

OIL ON CANVAS, 66 × 124 CM. C.1870-2. LONDON, NATIONAL GALLERY

The dating of this work has been much disputed. Martin Davies in his catalogue of the National Gallery collection dates it *c*.1881, but since the model is clearly Lise Tréhot, it must date not later than 1872, when Lise married Georges Brière de l'Isle, an architect, and evidently did not see Renoir again. Anthea Callen (*Renoir*, 1978) suggests that it predates the paintings of La Grenouillère, although she acknowledges that it has strong technical similarities to a dated 1871 work, the *Portrait of Madame Darras* (New York, Metropolitan Museum of Art). François Daulte in his *catalogue raisonné* also dates the painting 1869.

The painting is virtually an *au naturel* counterpart to the contrived glamour of the *Odalisque* (Plate 8). Lise's gaze confronts the spectator directly and her body is turned towards the viewer without coquetry. The candour of her look and pose makes this work a more private record of Renoir's relationship with Lise than the paintings for which she posed that were intended for Salon submission.

Lise's skin is milky white, in striking contrast to her dark eyes and eyebrows. The delicate handling of blue and pink tones on the skin, especially on the legs, suggests that Delacroix's influence was beginning to supplant that of Courbet.

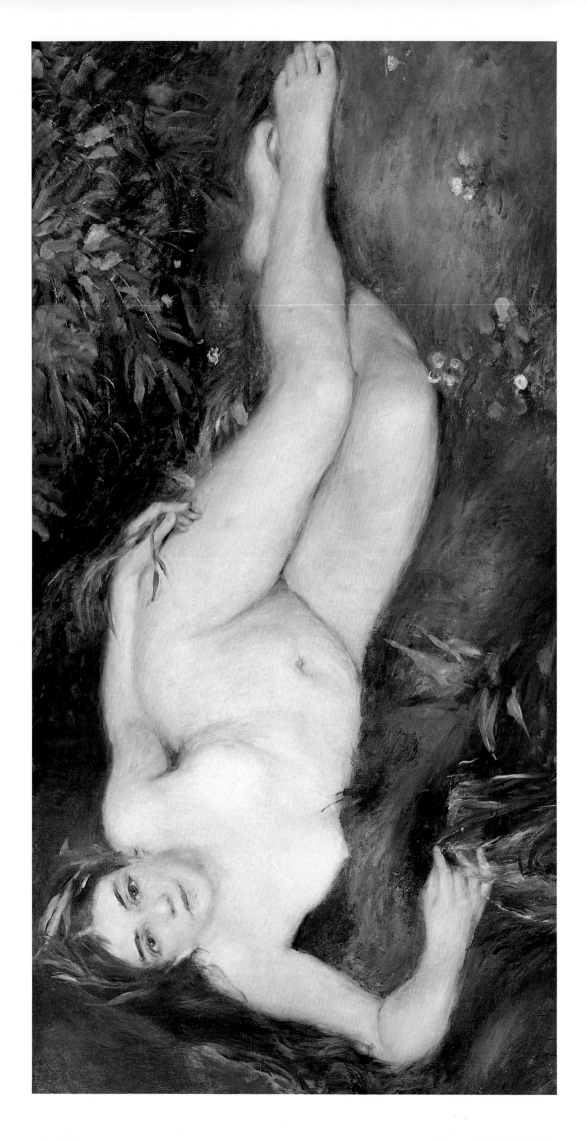

Claude Monet Reading

OIL ON CANVAS, 61 × 50 CM. 1872. PARIS, MUSÉE MARMOTTAN

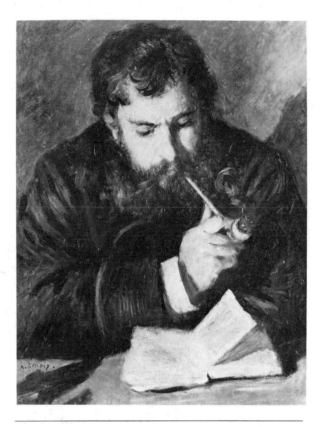

Renoir and Monet met at Gleyre's atelier in 1862 and often worked together during the 1860s and early 1870s. After his return to France from England and Holland in 1871, Monet rented a small house at Argenteuil near Paris, and Renoir joined him there frequently. The two men regularly set up their easels side by side and on one occasion, forty years later, were unable immediately to identify who had painted one of these canvases.

This portrait of Monet is one of several Renoir painted (see Fig. 16) and was formerly in Monet's own collection. It is clearly the result of long familiarity with the sitter, for Monet's pose is extremely relaxed and Renoir's execution suggests an equal degree of fluency and ease, in contrast to the companion portrait of Madame Monet (Plate 11).

The arm of the chair, Monet's yellow pipe, and flecks of intense yellow on his beard and skin serve to complement the sombre blue of the jacket, hat and background, and the indoor lighting of the scene dramatically accentuates the face and hand.

Fig. 16
Claude Monet

OIL ON CANVAS, 61.6 × 50.2 CM. 1872. WASHINGTON D.C., THE
COLLECTION OF MR AND MRS PAUL MELLON

Portrait of Madame Claude Monet

OIL ON CANVAS, 61 × 50 CM. 1872. PARIS, MUSÉE MARMOTTAN

This portrait of Camille Monet is identical in size to that of *Claude Monet Reading* (Plate 10) and was also in Monet's own collection, which was later bequeathed to the Musée Marmottan by Monet's son Michel.

Camille, née Doncieux, was born in Lyons in 1847 and married Monet in 1870. She died in September 1879. Renoir painted her portrait on several occasions. This painting is lightly worked and lacks the authority of Monet's portrait. Madame Monet appears ill at ease, plucking at her cravat and glancing sideways, and Renoir's treatment of the mouth and chin is unresolved. The wall behind the figure is yellow, overlaid with blue applied wet-on-wet, resulting in a greenish tonality, and details like the chair-back are suggested by cursory outlines, unlike the more elaborate handling of the chair in Monet's portrait.

The pair of portraits may be compared to Renoir's later portraits of Victor Chocquet and his wife (Plate 23 and Fig. 21), who were also observed by Renoir in their own surroundings.

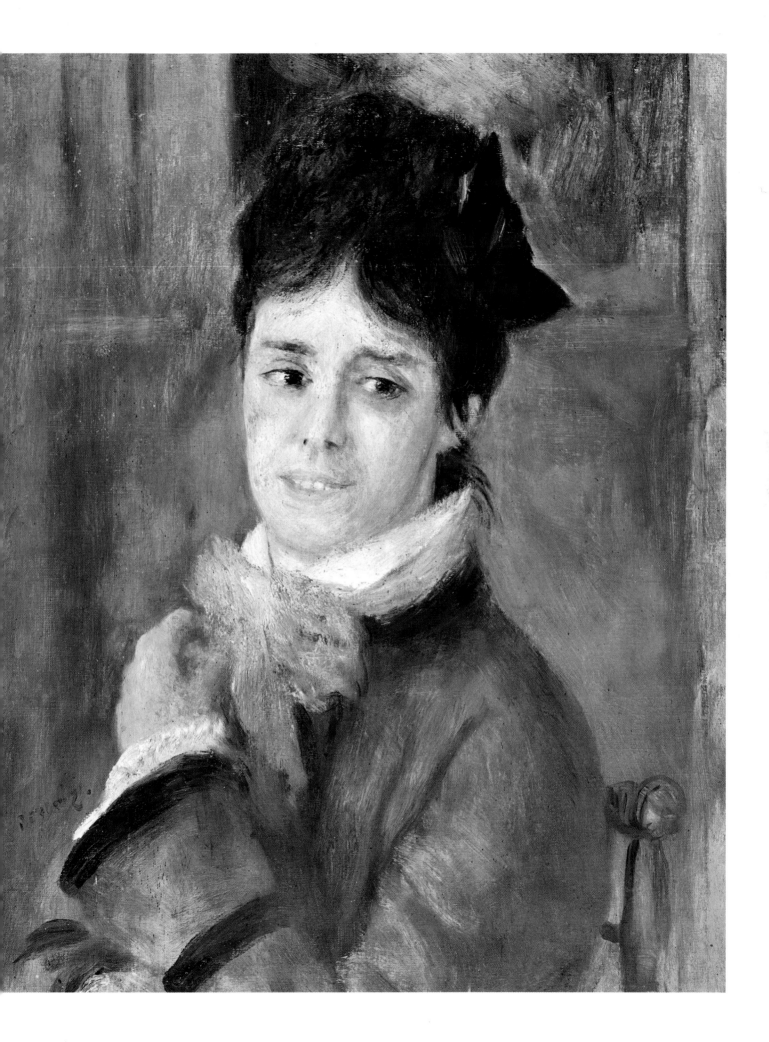

Path Winding Through High Grass

OIL ON CANVAS, 60 × 74 CM. C.1873. PARIS, LOUVRE (JEU DU PAUME)

Although sometimes dated *c.*1876, this painting is similar to Renoir's dated *Meadow* of 1873 (New York, Collection Siegfried Kramarsky) and the *Harvesters* (Zurich, Collection E.G. Bührle), also dated 1873. The high summer motif is also closely related to Monet's *Wild Poppies* (Paris, Louvre), dated 1873, especially in the importance of the placing of the figures.

Both paintings have two figures at the top of a slope and two figures lower down the slope, approaching the spectator. In both cases, although they are clearly two separate sets of figures, the effect is to create a sense of movement down the slope, which effectively combines with the brushwork's emphasis of movement by its changes in direction and staccato effect.

Renoir uses the vivid scarlet of the poppies to lift the overall colour intensity of the painting, in contrast to the dark green of the foreground bushes and the middle-ground trees. The red accent of the woman's parasol, almost in the centre of the painting, links with foreground scarlet touches. Renoir sets up a tension between the deep spatial recession suggested by the path and the flattening effect of the linked colour touches, the use of the figures discussed above, the central poplar tree's extension beyond the confines of the picture, and the flatness of the washy application of pigment. The impasted white of a bush in the foreground, the woman's blouse and the path itself is in marked contrast to the remainder of the canvas.

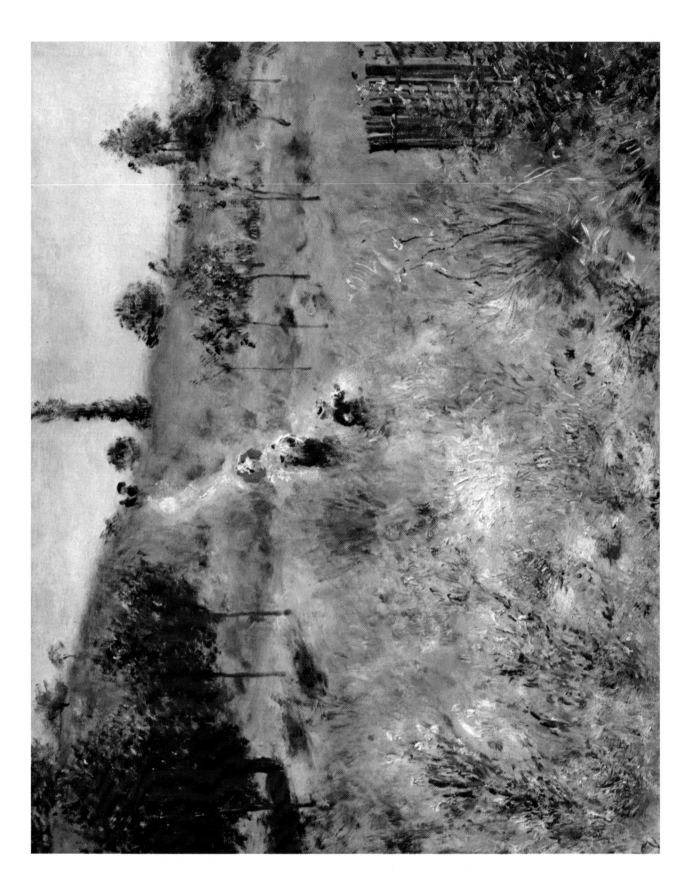

Summer Landscape

OIL ON CANVAS, 54 × 65 CM. C.1873. PRIVATE COLLECTION

In this small painting Renoir shows his development towards fully-fledged impressionism. The brushstroke used is short and fleck-like, varying in direction according to the surface being described, and there is extensive use both of pure colour and of areas of juxtaposed complementary colours. The clumps of flowers in the foreground are not depicted with any attempt to show botanical detail, but to convey the effect of a swaying mass of brilliant colour – red blooms vivid against the green of stems and grass, yellow and blue dabs of fairly thickly applied paint mutually enhancing each other.

The space in the painting is compressed by the virtual elimination of any sense of the horizon. The figures in the distance are relatively unimportant, unusually for Renoir, although the standing figure in her dark dress (which is blue, not pure black), holding a light parasol, is placed almost exactly on the vertical centre of the canvas and is further accentuated by the two small areas of blue sky above her.

It is interesting to note that Renoir's signature, which may be a later addition, as it frequently was, is pure black and there appear to be touches of black in the extreme foreground near the signature, in spite of the Impressionists gradual renunciation of black and the often-repeated statement that they eliminated black from their palettes altogether.

'La Parisienne'

OIL ON CANVAS, 160 × 106 CM. 1874. CARDIFF, NATIONAL GALLERY OF WALES

This painting was shown at the first Impressionist Exhibition in 1874 and was purchased a year later by Henri Rouart. The model is the actress Henriette Henriot, who posed for another portrait about two years later (Fig. 17).

The influence of both Velázquez and Manet is apparent in the setting of the figure in an undefined space, harshly frontally lit so that only a slight shadow on the left of the skirt gives any indication of depth. Madame Henriot's striking dark eyes and precisely drawn eyebrows are sharply defined. The vivid blue of her fashionable gown, gloves and hat is contrasted with her yellow earrings and gold bracelet, and she has the coppery hair which Renoir obviously found particularly attractive.

Paul Signac wrote of this painting in 1898: 'The tricks of colour are admirably recorded. And it is simple, it is beautiful and it is fresh. One would think that this picture painted twenty years ago had only left the studio today.'

Fig. 17 (left)
Portrait of Madame Henriot (detail)

OIL ON CANVAS, 70 × 55 CM. C.1876. WASHINGTON D.C., NATIONAL GALLERY OF ART. GIFT OF THE ADELE R. LEVY FUND, INC.

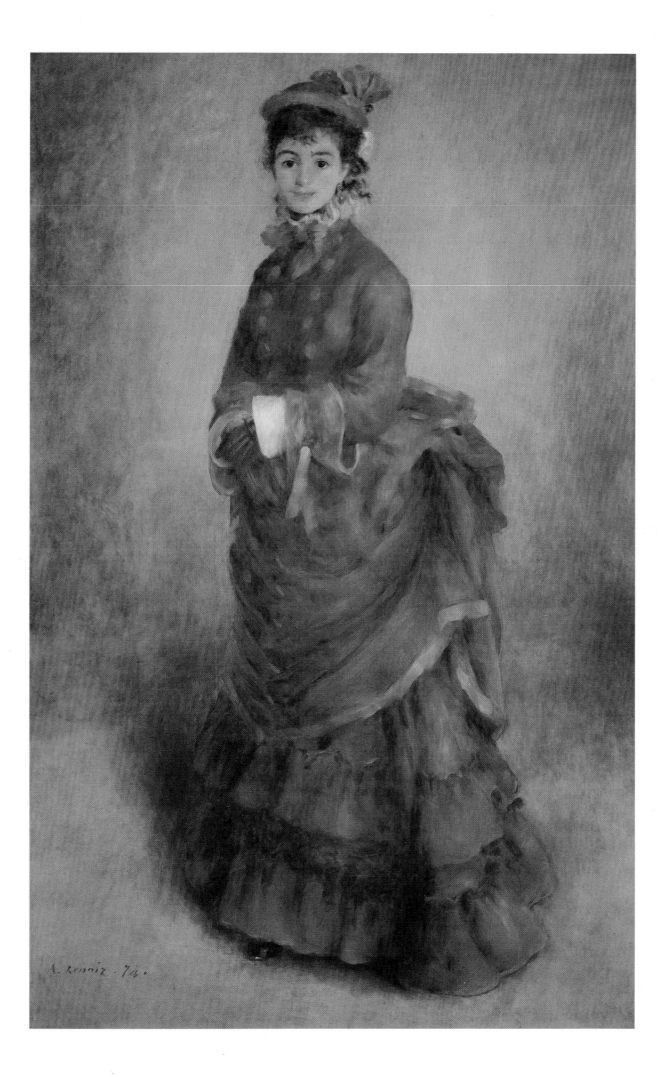

The Dancer

OIL ON CANVAS, 142 × 94 CM. 1874. WASHINGTON D.C., NATIONAL GALLERY OF ART (WIDENER COLLECTION)

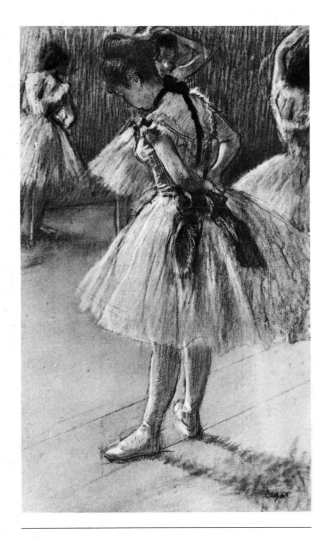

This painting was exhibited at the first Impressionist Exhibition in 1874. It displays Renoir's concern with the figure, especially the female figure. The young, slightly plump girl is wearing the costume of a dancer, as Lise had worn the costume of an Algerian in the *Odalisque* (Plate 8), and contrasts to Degas's many representations of the dancers of the *corps de ballet* (Fig. 18). She poses self-consciously, and the gauzey tutu is carefully complemented with bracelets, a black ribbon around her neck and a frothy blue ribbon in her hair.

The pose and indeterminate space relate this painting to Manet's picture of a Spanish dancer, *Lola de Valence* (Paris, Louvre), but the colouring is far more delicate and subdued than in Manet's painting. The black ribbon around the neck serves to accentuate the girl's fair skin and coppery hair, and prevents the closely related high value tonality of the canvas from appearing insipid.

The painting is executed on a canvas with a beige ground which shows through in many places. On this Renoir has laid in the background with paint heavily diluted with turpentine, formulating a method of painting that would reveal the transparent potential of oil colours.

Fig. 18
EDGAR DEGAS
Dancers Rehearsing

PASTEL AND CHARCOAL ON PAPER, 49.5 × 32.3 CM. C.1878. PRIVATE
COLLECTION

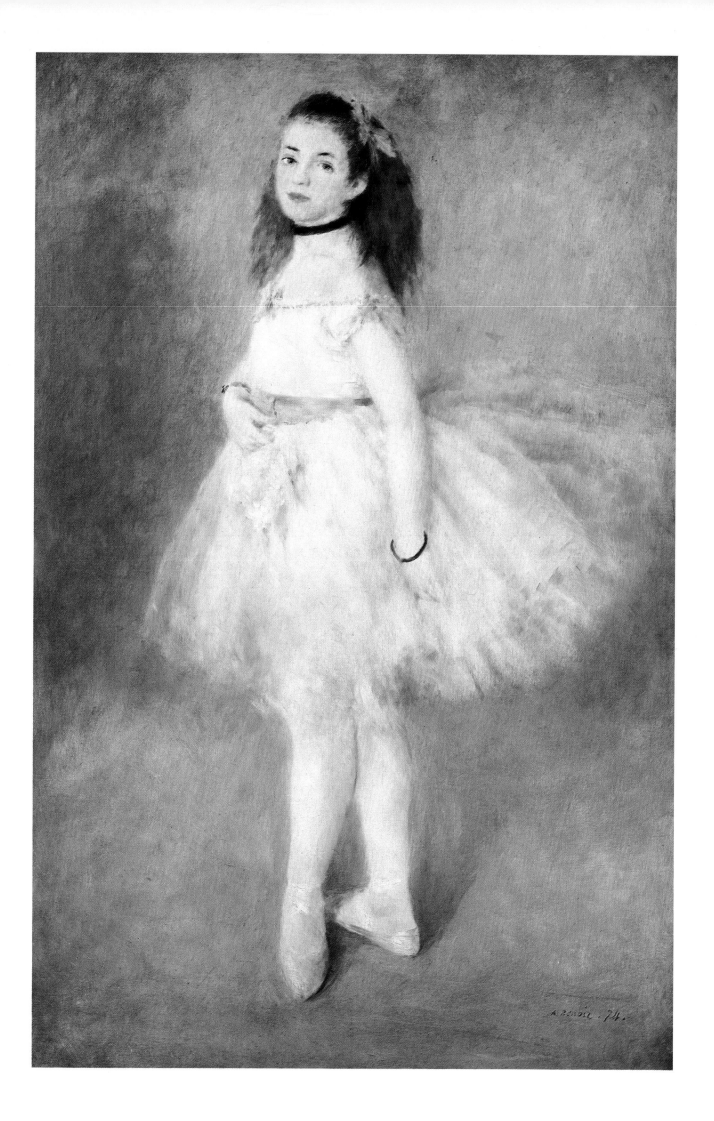

'La Loge'

OIL ON CANVAS, 80 × 64 CM. 1874. LONDON, COURTAULD INSTITUTE GALLERIES

A Montmartre model called Nini '*Gueule de raie*' and Renoir's brother Edmond posed for this painting, which was exhibited at the first Impressionist Exhibition in 1874. The dealer Père Martin bought the painting for 425 francs. Renoir painted three other versions of the same subject, one very small, only 27 × 22 cm., one considerably larger, dated 1876, and a third which was formerly in the collection of Georges Viau.

The painting is a *tour de force*, a modern-life painting (compare Fig. 19) in which Renoir has captured in the thin, delicate washes of pigment with impasto highlights details such as the earrings and the pearls, the opulence of the model's gown, the contrast between the black-and-white clothing and the delicate tones of her skin (emphasized by the rose in her bodice and in her hair), the glitter of her bracelet and opera-glasses, and her air of expectancy as she leans slightly forward. The male figure is literally connected to the female, the black stripe of her gown becoming the shoulder of his jacket, and he acts as a foil to her fairness and elegance. At the same time his attention is elsewhere, directed at something or someone outside the box.

Fig. 19
In the Bois de Boulogne

OIL ON CANVAS, 261 × 226.1 CM. 1873. HAMBURG, KUNSTHALLE

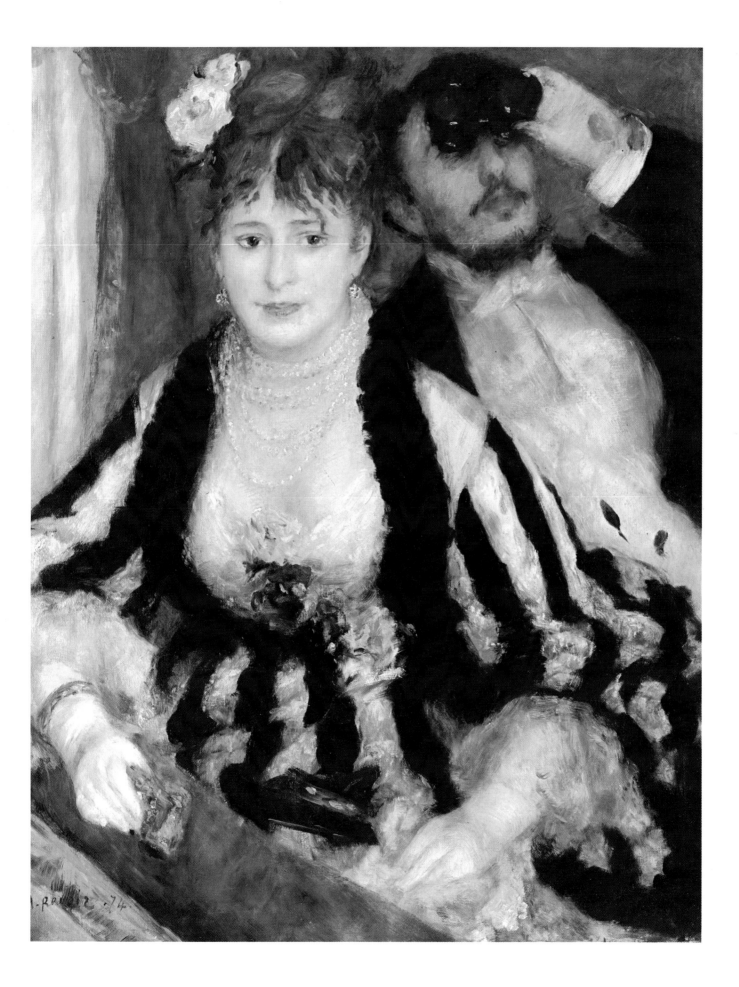

Madame Monet and Her Son

OIL ON CANVAS, 50 × 68 CM. 1874. WASHINGTON D.C., NATIONAL GALLERY OF ART, AILSA MELLON BRUCE COLLECTION

During the summer of 1874 Renoir visited the Monet family at Argenteuil on many occasions. In this painting, formerly in Monet's collection, he shows Camille Monet sitting pensively on the grass, chin propped on her hand in dreamy relaxation, while her son Jean, then aged seven, sprawls against her. Edouard Manet painted this scene at the same time, including more of the surroundings than Renoir, who has merely indicated a slender tree-trunk and the presence of some shrubs in the background.

Manet is alleged to have said to Monet, indicating Renoir, 'He has no talent at all, that boy! You, who are his friend, tell him please to give up painting' but the remark seems improbable and is certainly inaccurate, for Renoir has captured without a superfluous brushstroke the mood of mother and son and the languid contentment of a summer's day.

The Angler

OIL ON CANVAS, 54 × 65 CM. C.1874. PRIVATE COLLECTION

At an auction held at the Hôtel Drouot on 24 March 1875, organized by Renoir, Monet, Sisley and Berthe Morisot, this canvas was purchased by Georges Charpentier for 180 francs. Charpentier then arranged to meet Renoir, and he and his wife (Plate 31) became Renoir's most important patrons for the next decade.

The painting is rapidly executed, using canvas with a beige ground on to which Renoir laid a thin wash of green. Employing line hardly at all, Renoir established the major areas of the canvas, rubbing the damp lay-in with a rag in some portions, for example the path to the left of the figures. Touches of scarlet and rose madder heighten the overall green of the painting, and the dark shadowed areas are produced with viridian, sometimes mixed with blues like French ultramarine, rather than by using black.

The impression is one of spontaneity, of covering the entire canvas simultaneously, but the details and the arrangement of the figures indicate that even in this apparently casual painting the total effect is carefully calculated.

The male model may be Renoir's brother Edmond, who frequently posed for him at this time.

On the Seine, near Argenteuil

OIL ON CANVAS, 47 × 57 CM. C.1874. PRIVATE COLLECTION

Renoir visited Monet at his rented home at Argenteuil frequently in 1874 and is likely to have painted this canvas during that year, although it is sometimes dated c.1876/7. In spite of the bare arms of the *canotier* and the white dress and parasol of his companion, this does not appear to be a summer painting, but rather an autumn one.

The short wide brush-strokes used in the foreground area of the canvas convey the impression of dense undergrowth without describing any specific detail. The trees on either side frame an opening through which the river and the opposite bank are seen. The placing of the trees on either side of the vertical central axis of the painting flattens space and links the house and trees on the opposite bank with the foreground. Monet's influence is suggested in the composition and handling of space. The palette is very subdued, without even the addition of the few small touches of vivid colour that occur frequently in Renoir's work of the early 1870s.

Renoir returned to this stretch of the Seine on other occasions until the late 1880s (Fig. 20).

Fig. 20
The Seine at Argenteuil

OIL ON CANVAS, 22 × 26 CM. 1888. PRIVATE COLLECTION

Girl Reading a Book

OIL ON CANVAS, 47 × 38 CM. C.1875-6. PARIS, LOUVRE (JEU DE PAUME)

Renoir's model was Margot, who appears in many of his paintings of the mid-1870s. She came from Montmartre, and her real name was Marguerite Legrand. Her death in February 1879 from typhoid fever caused Renoir great distress.

In this painting, which belonged to Gustave Caillebotte, Renoir used a smaller and more delicate brush-stroke than had previously been the case, resulting in a more intricate mix of colour. This is particularly noticeable in the ruffle at the neck where the blend of blue, red, yellow and rose creates an almost tapestry-like intricacy of modulation. Renoir also juxtaposes larger areas of approximately complementary colour. There is a blue-green area on the right-hand side of the canvas adjacent to a yellow-pink area directly behind the model's head, and there is a great deal of yellow on the face, ruffle and hand.

The simplicity of the pose and the importance of the rectangular panels on the wall in establishing a highly organized composition suggest the influence of Vermeer and of Chardin, both of whom Renoir is known to have admired greatly.

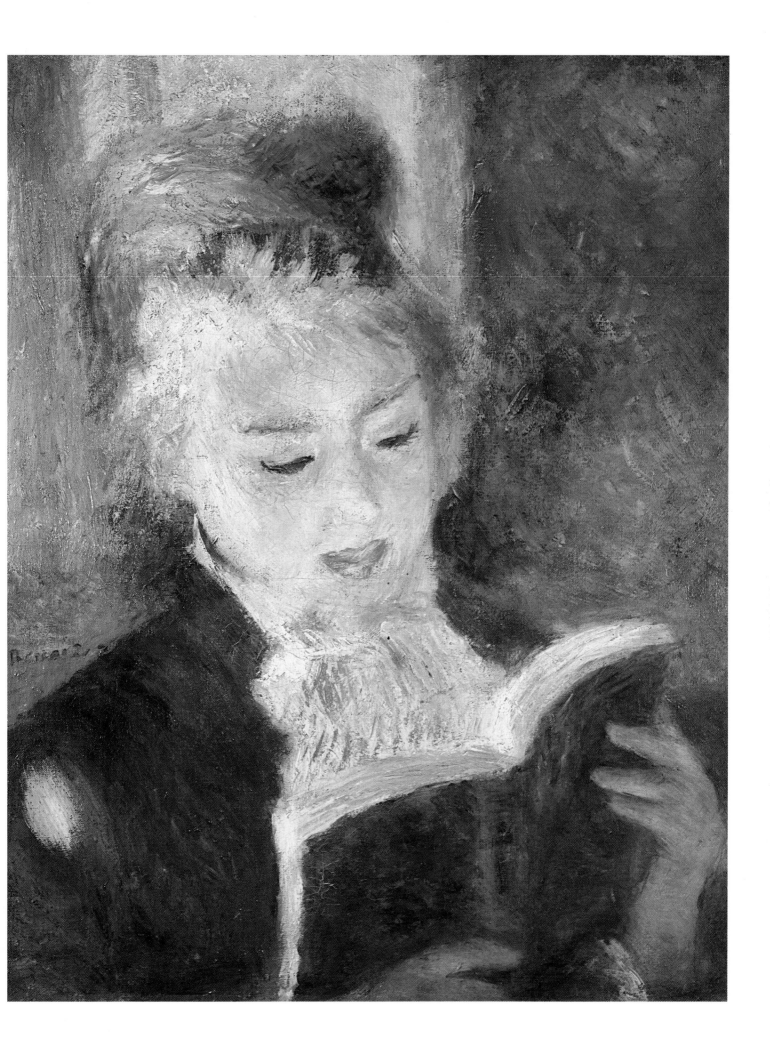

Scene in Renoir's Studio, Rue St Georges

OIL ON CANVAS, 45 × 37 CM. C.1876. PRIVATE COLLECTION

Renoir's studio at 35 rue St Georges was a meeting-place for his friends and he was always 'at home' on Thursday afternoons. He used this studio for painting portraits and nudes, and the Montmartre studio for his outdoor work.

This painting depicts a typical gathering of his companions, deep in conversation. On the left is the painter Franc-Lamy, who had staged an unsuccessful revolt against Ingres's former master at the École des Beaux Arts, Henri Lehmann, and had been forced to leave the École. In the centre is Georges Rivière, a close friend of Renoir's and later his biographer. Next to him, seen in profile, is Camille Pissarro, looking considerably older than his forty-six years. The relationship between Pissarro and Renoir was strained by disagreements about the organization of the Impressionist exhibitions and by political differences in the 1880s and again at the time of the Dreyfus trial, but at this period they were close and both men were very involved in the planning of the third Impressionist show, held in 1877. Lestringuez is at Pissarro's side, and in the foreground is the musician Ernest-Jean Cabaner.

Renoir's dislike of professional models meant that he relied heavily on his friends' willingness to pose for him, and Lestringuez, Franc-Lamy and Rivière frequently obliged him.

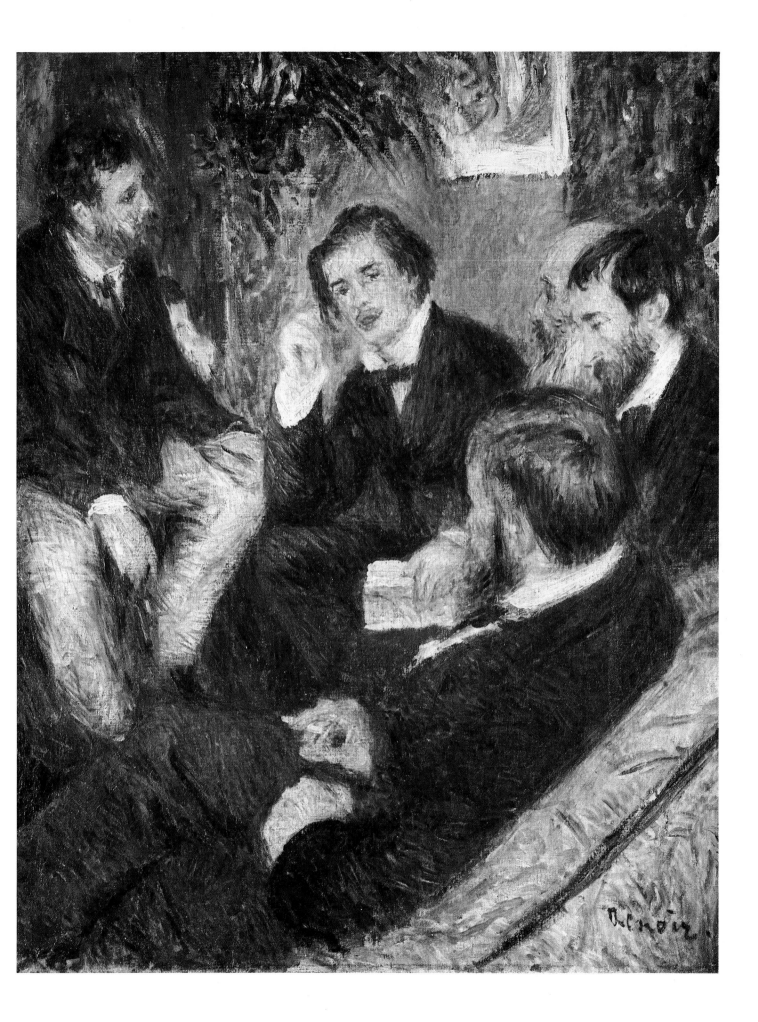

Female Nude

OIL ON CANVAS, 92 × 73 CM. C.1876. MOSCOW, PUSHKIN MUSEUM

This painting, formerly in the collection of the composer Emmanuel Chabrier, was probably painted in the rue St Georges studio, and is an example of a genre that Renoir never entirely abandoned, although in the years of his closest association with Claude Monet the problems of light and colour observed *en plein air* took precedence over nude paintings.

The model, Anna, is of the broad-hipped, translucent-skinned type that Renoir always favoured, similar to Aline Charigot who later became his wife. The background is entirely undifferentiated, a swirl of fabric strewn on upholstered furniture, a foil to the dark-eyed, dark-haired nude. The painting is deliberately composed, with the nude looking over her shoulder at the spectator in an archetypically provocative pose while at the same time presenting only her back and a portion of her breast for view.

Renoir was indebted to eighteenth-century French painting throughout his life, and in paintings like this he extends the tradition of Boucher and Fragonard into the late nineteenth century.

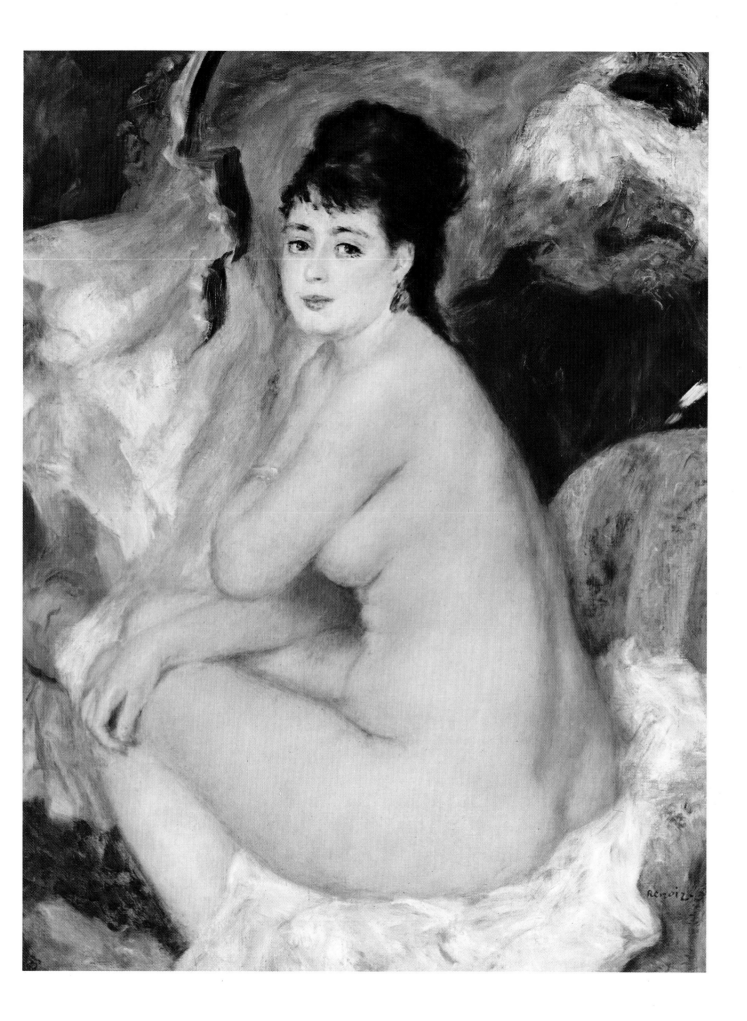

Portrait of Victor Chocquet

OIL ON CANVAS, 46 × 36 CM. C.1876. WINTERTHUR, OSKAR REINHART COLLECTION

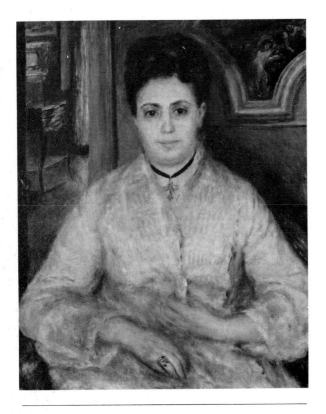

Fig. 21
Madame Victor Chocquet

OIL ON CANVAS, 75 × 60 CM. 1875. STUTTGART, STAATSGALERIE

Renoir met Victor Chocquet at the Hôtel Drouot auction in 1875 and Chocquet immediately requested him to paint a portrait of Madame Chocquet (Fig. 21). Renoir told Vollard that Chocquet found qualities in his work that reminded him of Delacroix, and that Chocquet had asked him to include a portion of a Delacroix – a sketch of *Numa and Egérie*, then in his collection – in the portrait of his wife, 'I want to have you together, you and Delacroix', Renoir recalled him saying.

Chocquet was an ardent proselytizer on the Impressionists' behalf; he tirelesssly attempted to persuade visitors to the 1876 exhibition of his convictions, and make them share his admiration and pleasure. 'It was a thankless task,' Théodore Duret later wrote, 'but Chocquet was not to be disheartened.'

This portrait was exhibited at the 1876 show, one of six Renoirs owned by Chocquet on view. It shows Chocquet in a characteristically gentle and pensive pose in his apartment at 204 rue de Rivoli. Chocquet was a customs official, and a discerning collector of antique furniture as well as of paintings. Renoir and Cézanne were his especial favourites among contemporary artists, and the sale of his collection on the death of his widow in 1899 included eleven Renoirs.

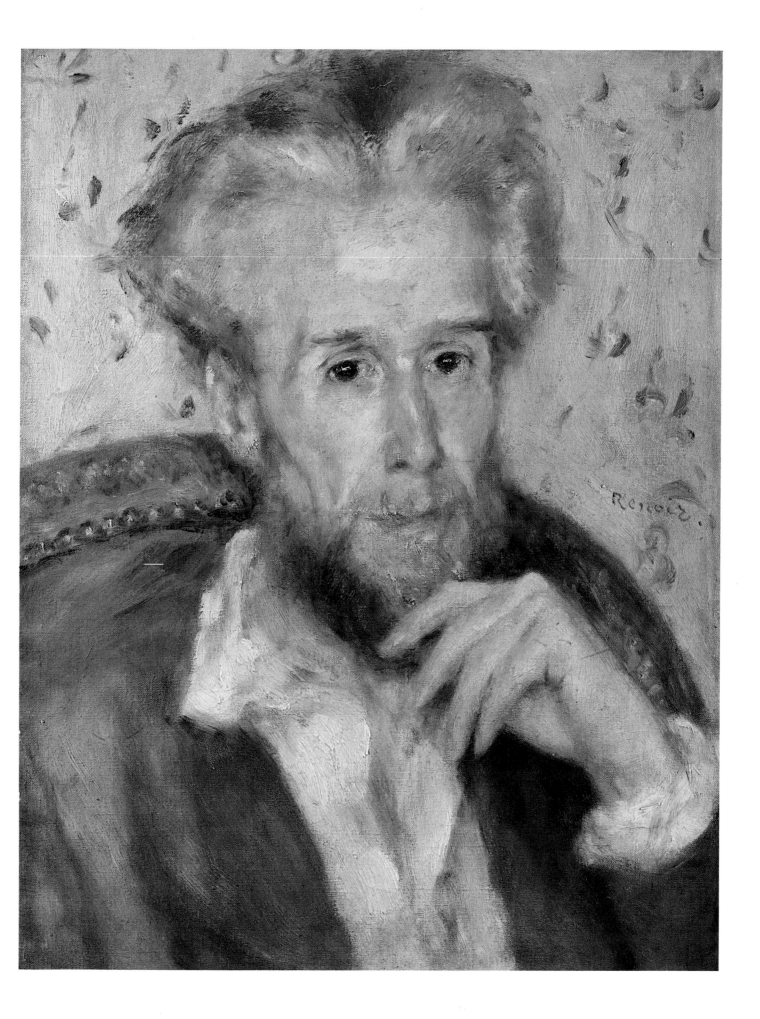

Under the Arbour at the Moulin de la Galette

OIL ON CANVAS, 81 × 65 CM. C.1876. MOSCOW, PUSHKIN MUSEUM

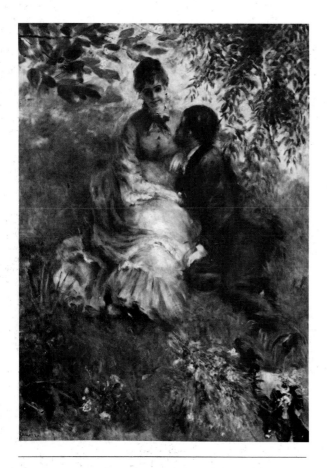

Fig. 22
The Lovers

OIL ON CANVAS, 175 × 130 CM. 1875. PRAGUE, NATIONAL GALLERY

Renoir rented a studio at 12 rue Cortot in Montmartre in April 1875. The house had formerly belonged to Rose de Rosimont, the actor who took over Molière's parts at his death. The studio consisted of 'two enormous rooms and a stable to store his canvases in' (Georges Rivière), and a large rambling garden.

From this base, Renoir began to work on a number of studies of the Moulin de la Galette, the popular open-air dance-hall on the Butte Montmartre. The Moulin de la Galette had a reputation for being a respectable place where working-class men and women met and enjoyed themselves, and it is this frank and open pleasure in life that Renoir captures. The canvas, formerly in the collection of Eugène Murer, shows a group sitting at a table under an arbour, drinking and flirting, watched by a standing female figure who might, from the similarity of costume and hair, be Estelle, the model for the foreground figure in Renoir's *At the Moulin de la Galette* (Plate 26).

Renoir suggests facial expressions and details with broad brush-strokes, and combines his delight in the people's activity with an intent observation of the dappling of light through the trees, and the strong blue shadows on the grass in the right foreground.

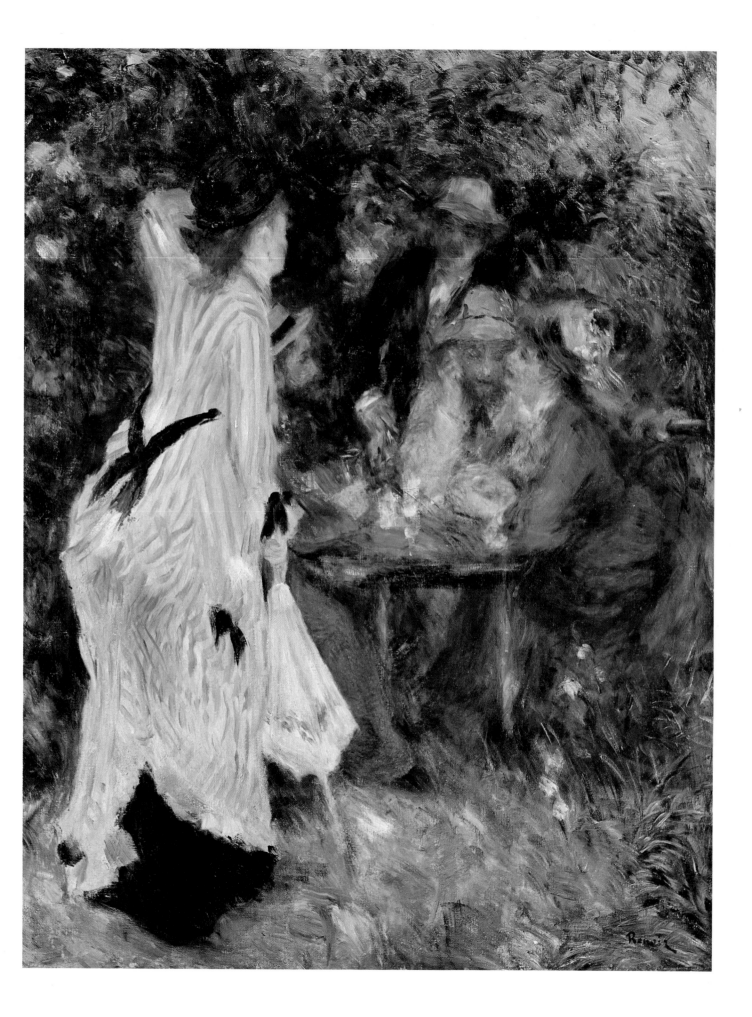

The Swing

OIL ON CANVAS, 92 × 73 CM. 1876. PARIS, LOUVRE (JEU DE PAUME)

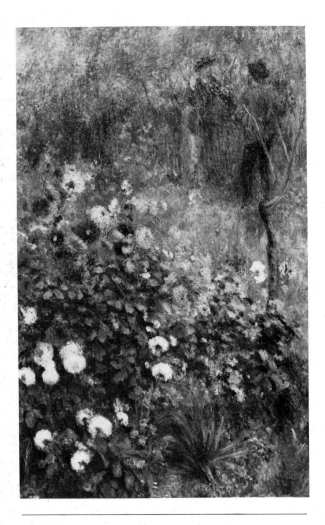

This painting, formerly in Gustave Caillebotte's collection, was executed in the large overgrown garden of 12 rue Cortot (see also Fig. 23). The model, Jeanne, a young actress, stands languidly on the swing, looking away from the men and the child. Renoir was interested at this time in capturing the effect of sunlight as it filtered through leaves and created splashes of colour and purple shadow areas, and in making an equivalent in paint of the constant changes and shifts in the light of the scene he was observing.

Yellow-orange and blue-purple tones are the basis of the painting, and Renoir studied not only the effect of juxtaposing large areas of these complementaries, such as placing the copper-haired woman in her white dress against the blue-suited man with his back to us, but also of adding touches of the complementary to the main areas. So this man wears a yellow hat, and Jeanne's white dress has blue bows. The effect of this is to create an overall vibrancy of colour that anticipates Seurat's more formal experiments in the use of colour-theory of the next decade.

Fig. 23
The Garden in the Rue Cortot, Montmartre

OIL ON CANVAS, 155 × 100 CM. 1876. PITTSBURGH, MUSEUM OF ART, CARNEGIE INSTITUTE

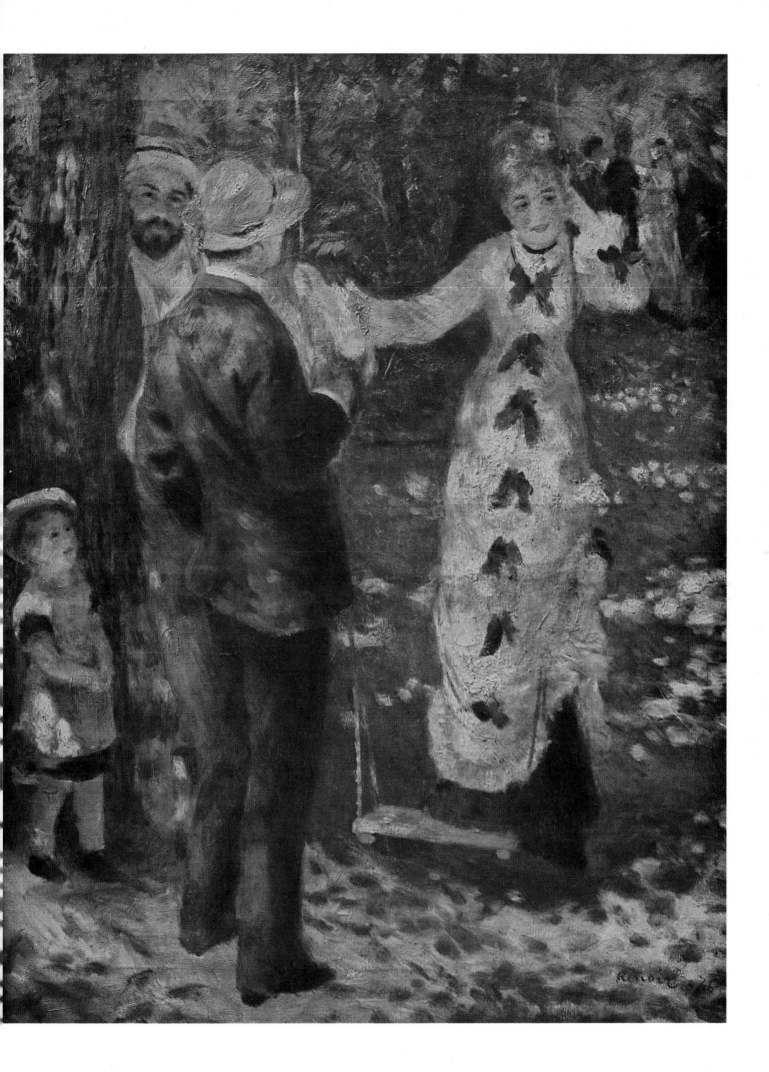

At the Moulin de la Galette

OIL ON CANVAS, 131 × 175 CM. 1876. PARIS, LOUVRE (JEU DE PAUME)

This large canvas was the result of many weeks of work at the Moulin de la Galette. Renoir's friends assisted him each day in moving the canvas from the rue Cortot studio to the Moulin. This version of the subject is the largest and most fully worked, and belonged to Gustave Caillebotte. A rapidly executed sketch is in the Ordrupgaard Museum, Copenhagen, and Victor Chocquet formerly owned the version that is now in the John Hay Whitney Collection, New York.

Many of Renoir's friends acted as models for the dancers, among them Franc-Lamy, Rivière, Cordey, Lhote and the painter Norbert Goenutte. In the foreground, seated at a table, is a model named Estelle, and in the middle-distance a favourite model of Renoir's, Marguerite Legrand, or Margot, dancing with a Spanish painter, Don Pedro Vidal de Solares y Cardenas.

Georges Rivière wrote of this testament to 'la vie moderne' in *L'Impressionniste* in April 1877: 'It is a page of history, a precious and strictly accurate memento of Parisian life. No one before Renoir had thought of taking some everyday happening as the subject for so large a canvas. His boldness is bound to have the success it deserves. We make a point of stressing here the very great significance this picture has for the future.'

The canvas was completed in September 1876 and exhibited at the third Impressionist Exhibition in 1877.

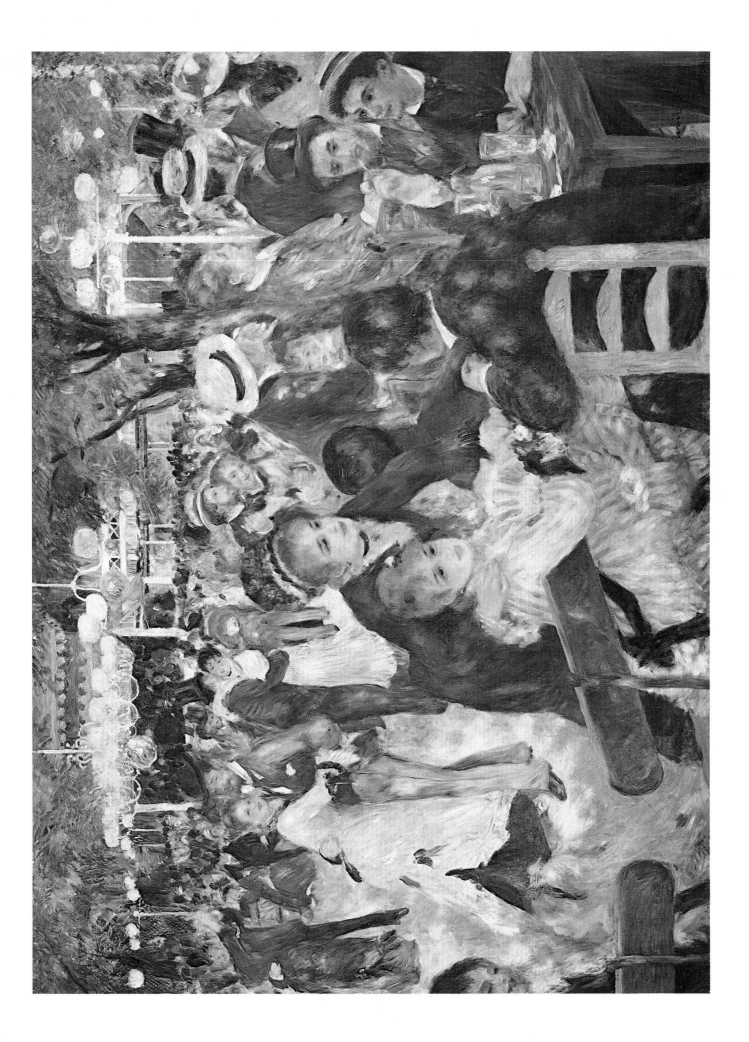

A Girl with a Watering-Can

OIL ON CANVAS, 100 × 73 CM. 1876. WASHINGTON D.C., NATIONAL GALLERY OF ART (CHESTER DALE COLLECTION)

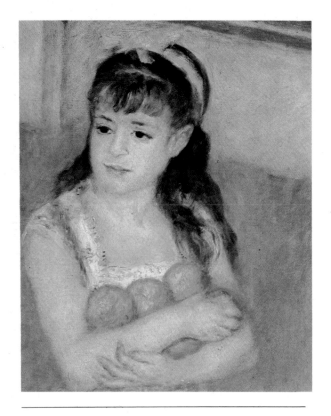

From the mid-1870s, thanks to Georges Charpentier's interest in his work, Renoir gradually began to acquire a rich bourgeois clientele, who requested portraits of themselves and of their families. This portrait of a young girl appears to result from these contacts. The elaborately dressed child, Mademoiselle Leclere, stands stiffly, holding the watering-can and flowers as if they have been thrust at her as props, to link her to the garden in which she stands. Renoir has recorded the delicacy of her colouring (compare Fig. 24), and the charm of her formality, without the spontaneity and vivacity with which he painted worlds in which he felt more at ease – the Moulin de la Galette, for example.

The garden in the background is painted in short, delicate brush-strokes on a beige-toned ground, and the flower-border is a series of dabs of saturated colour, closely comparable to Monet's technique. There is no indication of a horizon-line. The red areas of the background and the red ribbon in the child's hair are of the same intensity, making them appear to be on the same spatial plane.

Fig. 24
Jugglers at the Cirque Fernando (detail)

OIL ON CANVAS, 131 × 99 CM. 1879. COLLECTION OF THE ART
INSTITUTE OF CHICAGO

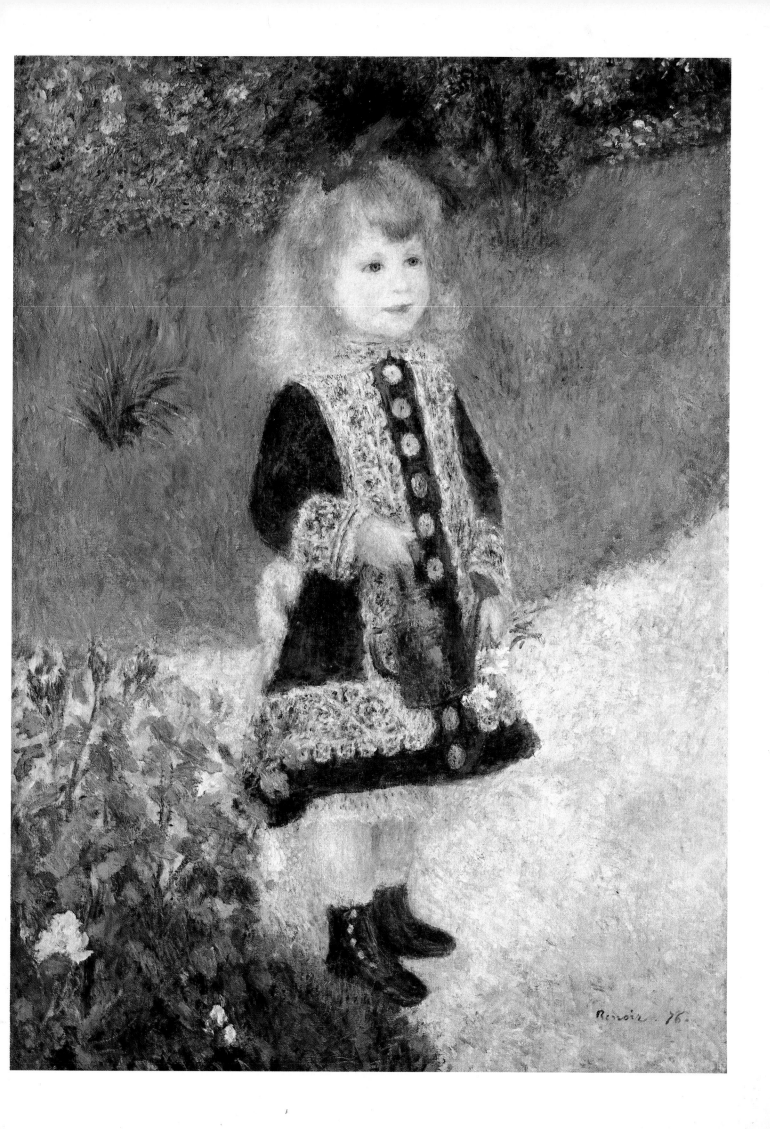

Roses in a Vase

OIL ON CANVAS, 61 × 51 CM. C.1876. PRIVATE COLLECTION

In striking contrast to paintings of the same period that are records of contemporary life, this informal arrangement of full-blown pink roses in a cylindrical vase allowed Renoir to concentrate on formal and colouristic problems, much as Cézanne did in his still-lifes. Renoir explores the relation of the rounded blossoms to the constraining vase with its spiralling decoration of open blooms; the rather precarious placing of the vase on the edge of the table; the compression of space of the background, with the leaves of the floral arrangement merging almost imperceptibly with the landscape painting hanging on the wall; and the tonal relation of the blooms to the salmon-coloured armchair.

The foreground is painted in broad, hasty strokes of thinly applied pigment, while the blooms are fairly heavily impasted in some areas, and pigment has been added wet-on-wet. This suggests that the painting was a brief exercise for Renoir, but, typically, one in which his enjoyment of the subject and its execution is evident to the viewer (Fig. 25).

Fig. 25
Still-Life with Strawberries

OIL ON CANVAS, 21 × 28.6 CM. 1914. PARIS, COLLECTION PHILIPPE GANGNAT

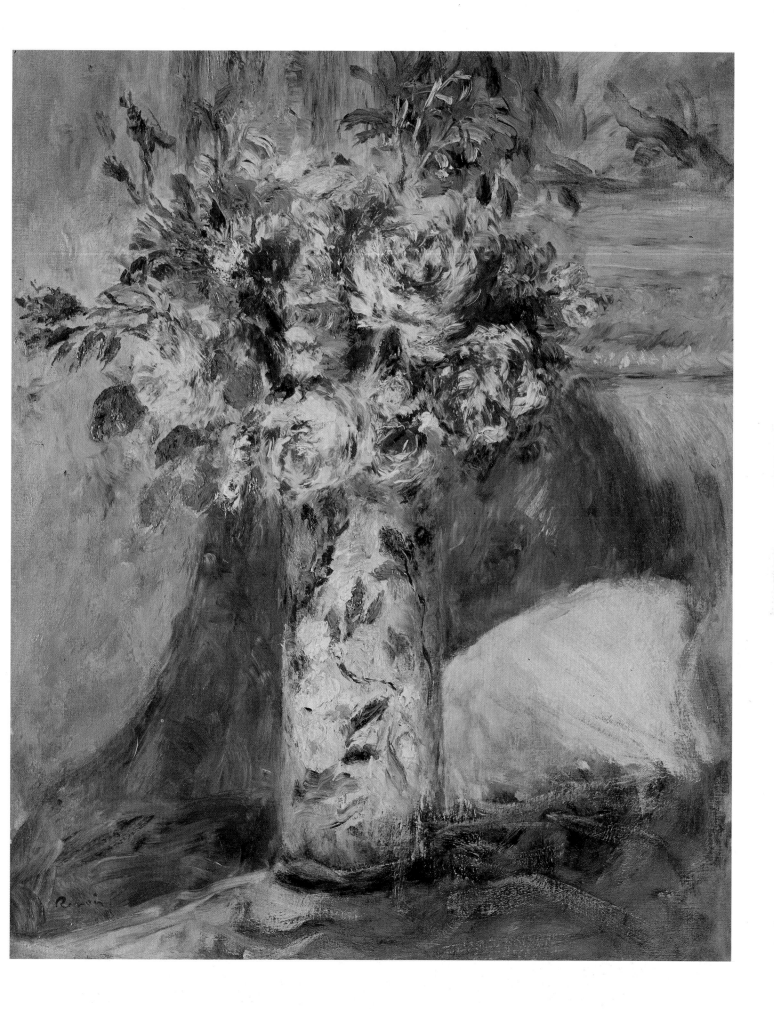

The Café

OIL ON CANVAS, 35 × 28 CM. C.1876-7. OTTERLO, KRÖLLER-MÜLLER MUSEUM

In this small painting Renoir has recorded an aspect of Parisian life that fascinated many of his contemporaries, among them Manet (Fig. 26) and Degas. The cafés were meeting-places, clubs, places to do business and to dally, and many a Parisian *flâneur* spent the greater part of his day strolling on the boulevards and sitting at his favourite café.

Renoir may have begun this painting on the spot and worked on the heads of the three major figures in his studio, since their handling is in contrast to the remainder of the canvas, which is very sketchily treated. The canvas is divided vertically by a background screen that serves to accentuate the three heads and set them apart from the group of figures in the right-hand half of the painting.

Renoir's models for this picture were his close friend Georges Rivière, Marguerite Legrand, or Margot, and Nini Lopez. Margot modelled regularly for Renoir in the late 1870s (see Plate 20) until she died of typhoid fever in February 1879.

Fig. 26
EDOUARD MANET
At the Café

OIL ON CANVAS, 78 × 84 CM. 1878. WINTERTHUR, OSKAR REINHART COLLECTION

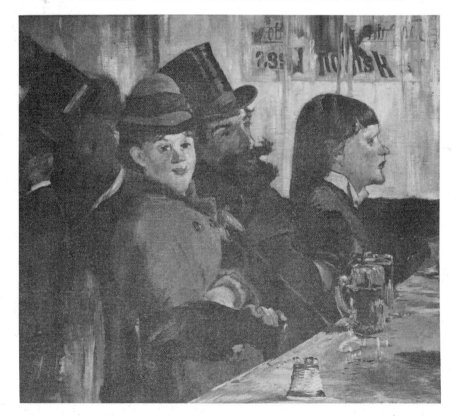

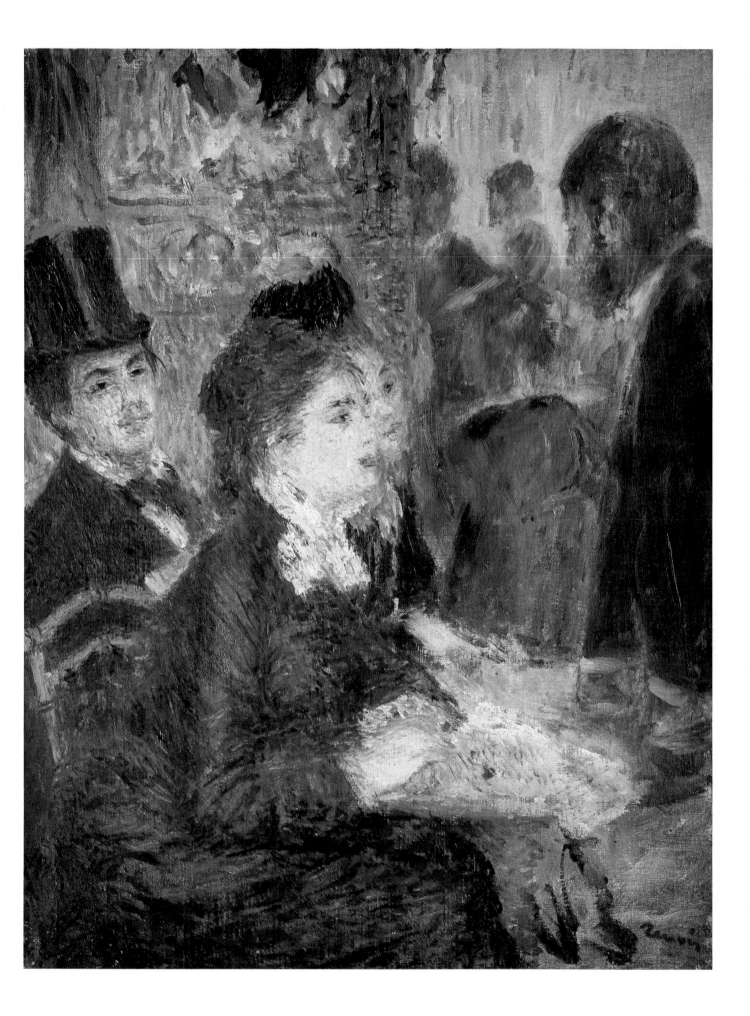

'La Première Sortie'

OIL ON CANVAS, 65 × 51 CM. C.1876-7. LONDON, NATIONAL GALLERY

As in *'La Loge'* (Plate 16), this painting depicts a visit to the theatre, but whereas Renoir concentrated on the two figures alone in the earlier painting, he here relates the figures in the box to their surroundings. The present title, which invites an anecdotal interpretation, was first given to the picture as late as 1923 in an exhibition catalogue. It seems originally to have been called *The Café-Concert*.

Renoir shows the young girl leaning slightly forward and clutching her posy of flowers. She gazes at the audience, which Renoir depicts in broad strokes, suggesting movement and lively discussion by the different directions in which the heads are turned.

In its brushwork and use of colour, particularly the yellow and blue contrasts that dominate the harmony of the canvas, the painting is confident and assured. Specific detail disappears in favour of a record of an impression of the whole scene.

The subjects of the theatre, the café-concert and the café were also attractive to Degas and Manet; like Renoir they were painters of 'la vie moderne', and were fascinated above all by the spectacle of contemporary Paris at leisure.

This painting was first purchased by Comte Doria, a relative of Madame Charpentier's, who had bought Cézanne's *La Maison du pendu* at the first Impressionist Exhibition.

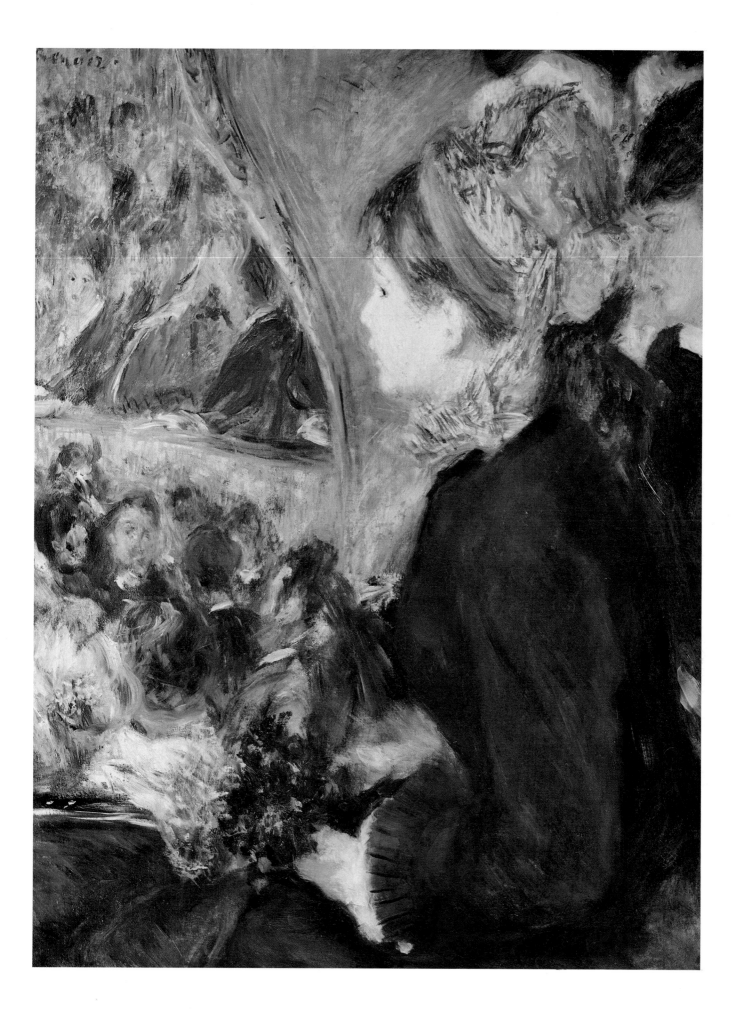

Portrait of Madame Charpentier

OIL ON CANVAS, 46 × 38 CM. C.1876-7. PARIS, LOUVRE (JEU DE PAUME)

Madame Charpentier was the wife of Georges Charpentier, owner of the publishing house, the *Bibliothèque Charpentier*. She and her husband were Renoir's most important patrons in the 1870s, after Charpentier's purchase of *The Angler* (Plate 18). Madame Charpentier's *salon* was a meeting-place for celebrities from the worlds of politics, literature and art. Regular visitors included Zola, Daudet, Flaubert and Edmond de Goncourt. Here Renoir was introduced to friends of Madame Charpentier's who commissioned paintings from him. This greatly aided his financial position and the mood of his paintings of figures from the *haut bourgeois* world of Madame Charpentier and her circle contrasts markedly with his delight in the more earthy pleasures offered by Montmartre.

Renoir enjoyed going to Madame Charpentier's parties because, as Georges Rivière said: 'Here he found himself in an intelligent milieu where, by the tact and grace of his hostess, haughtiness and boredom were banished. Here he felt himself understood, encouraged by the welcome of the friends he met.'

Renoir told Vollard that Madame Charpentier bore a certain resemblance to Marie-Antoinette and in this portrait he contrives to give her a faintly regal air by the tilt of her head and the aloofness of her expression. His portrait of Madame Charpentier and her children Georgette and Paul (Fig. 27) was accepted for the Salon of 1879 because of Madame Charpentier's position in society, and it brought Renoir considerable success.

Fig. 27
Madame Charpentier and Her Children

OIL ON CANVAS, 153.7 × 190.2 CM. 1878. NEW YORK, THE METROPOLITAN MUSEUM OF ART
(PURCHASE, WOLFE FUND, 1907)

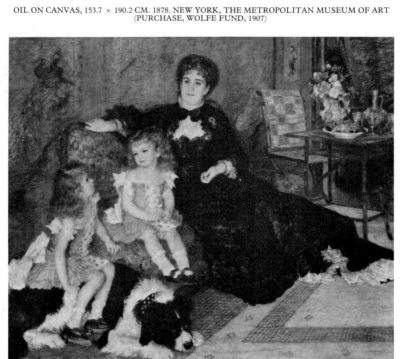

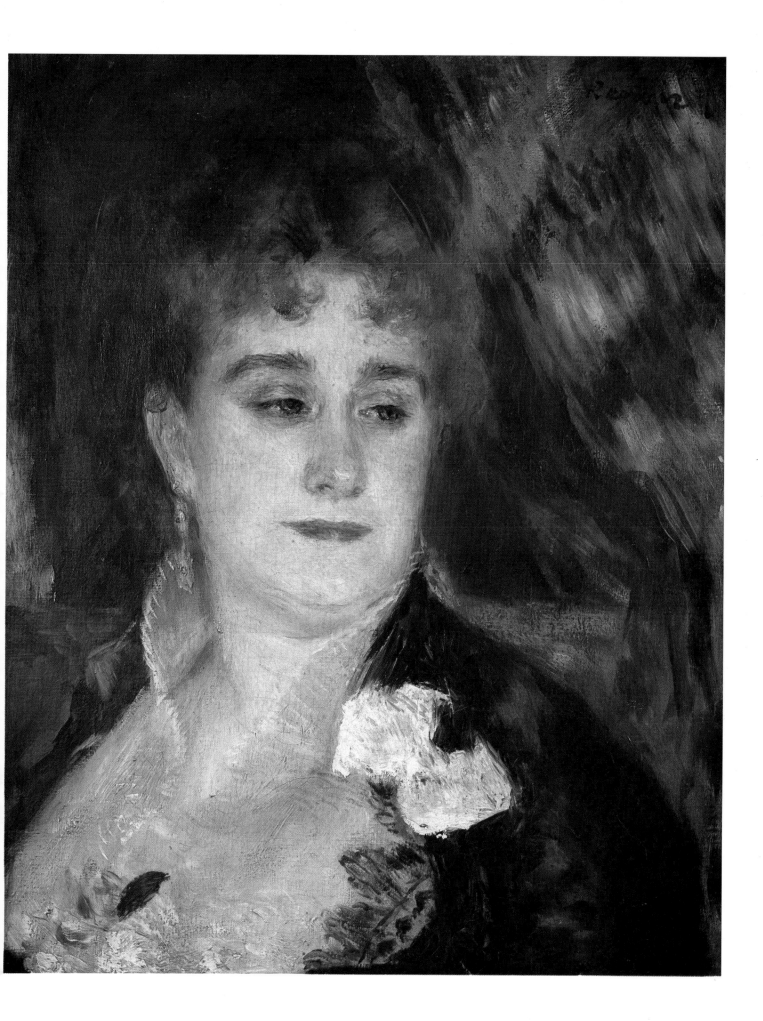

Oarsmen at Chatou

OIL ON CANVAS, 81 × 100 CM. 1879. WASHINGTON D.C., NATIONAL GALLERY OF ART (GIFT OF SAM A. LEWISOHN)

Renoir visited Chatou on the Seine, close to La Grenouillère (Plate 6), in the summer of 1879, and painted this view of the river on a bright, sunlit day. On the bank in the foreground is the painter and collector Gustave Caillebotte, an enthusiastic yachtsman and *canotier* who lived at Petit Gennevilliers on the opposite bank of the Seine from Argenteuil. The woman next to Caillebotte is Aline Charigot, Renoir's future wife. Aline was a seamstress whom Renoir had met at the *crémière* where he frequently took his meals. Aline came from Essoyes in the Aube district and was the daughter of a vine-grower who had left his family and emigrated to the United States. In this painting she is fashionably attired, lifting the hem of her dress to show the flounced petticoat and glancing up from under the brim of her hat in a flirtatious fashion.

The mood of the painting and the technique employed, varying the size and direction of the brush-stroke according to the surface being described, are characteristically impressionist, recalling paintings of some five years earlier and have no hint of the doubts Renoir was to experience about his approach to painting in the early 1880s.

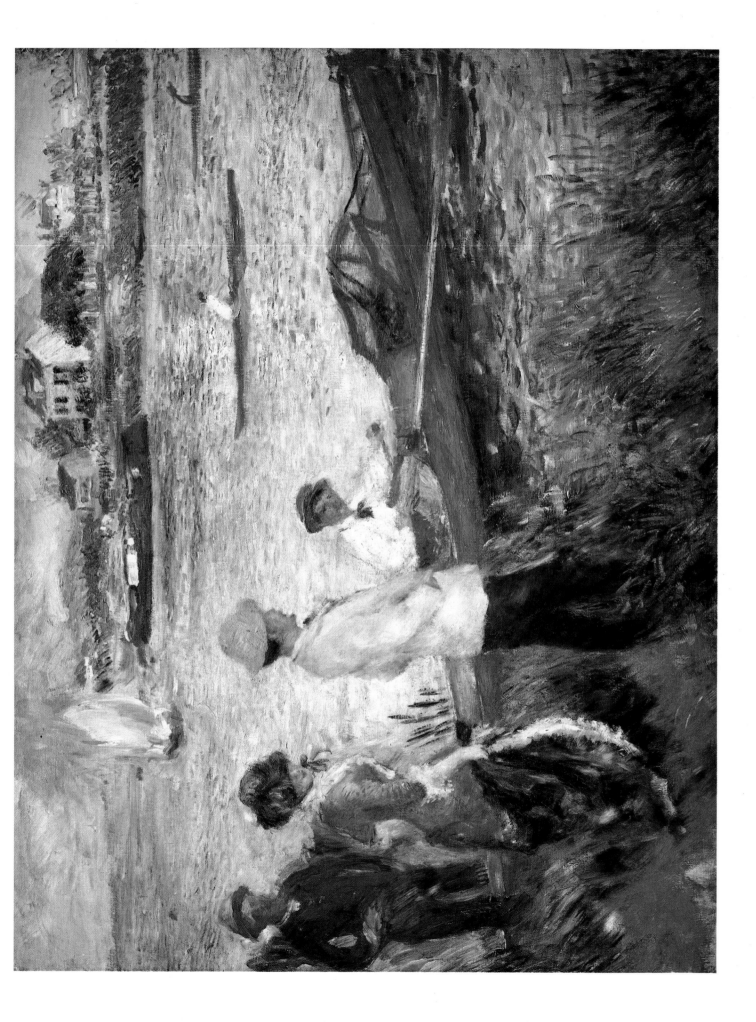

The Skiff

OIL ON CANVAS, 71 × 92 CM. C.1879. LONDON, NATIONAL GALLERY (ON LOAN)

Asnières on the Seine was an area that was to attract the attention of Seurat, Signac, Émile Bernard and Van Gogh in the 1880s. Its proximity to central Paris made it easily accessible and convenient.

Renoir's painting shows a sunny day, with the two women drifting lazily in the skiff. The vivid yellow and orange skiff contrasts with the blue of the river, casting orange reflections on the water, and throughout the canvas the juxtaposition of yellow and blue is emphasized. The dark plume and trailing scarf of the rowing figure's hat create a strong, centrally placed accent.

The train approaching the railway-bridge typifies the Impressionists' easy acceptance of the changes industrialization had made to the landscape. The smoke is linked formally to the large round light marking the bridge.

Paint is applied to the canvas in short strokes, varying according to the texture described. A dense surface of short, dry dabs of paint marks areas such as the reflection of the house in the water, while the green foliage on the banks of the railway-line is softer and less differentiated.

This painting was one of Victor Chocquet's collection of eleven Renoir canvases.

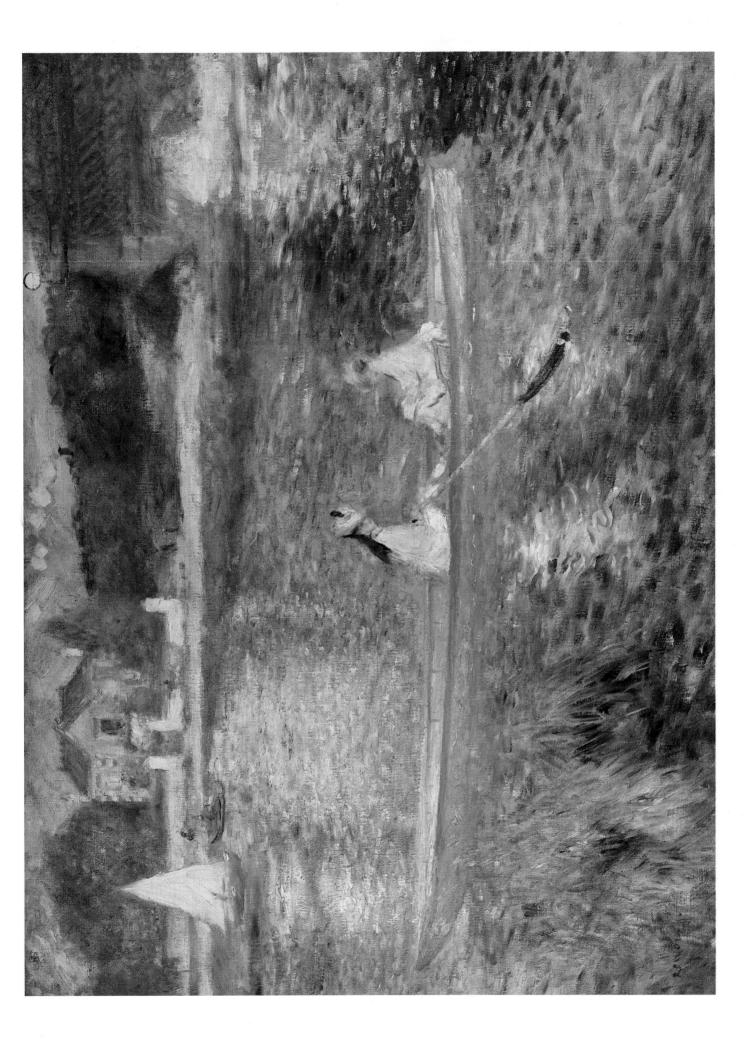

The End of the Lunch

OIL ON CANVAS, 100 × 81 CM. 1879. FRANKFURT-AM-MAIN, CITY ART INSTITUTE

Renoir depicted figures enjoying a meal on several occasions: compare for example *The Luncheon* (Fig. 28) and *The Luncheon of the Boating Party* (Plate 36). This relaxed group was painted in the garden of the Cabaret d'Olivier in Montmartre. The woman holding a glass is the actress Ellen Andrée who also appears in Degas's *L'Absinthe* (Paris, Louvre). The man shown lighting a cigarette at the extreme right-hand edge of the canvas is Renoir's brother Edmond. Edmond wrote of his brother's painting at the time of this canvas: 'Does he make a portrait? He begs his model to maintain a customary attitude, to seat herself the way she naturally does, to dress as she dresses, so that nothing savours of constraint and preparation.

Thus his work has, aside from its artistic value, all the charm *sui generis* of a faithful picture of modern life. What he paints, we see every day; it is our very existence that he has registered in the pages which are certain to remain among the most living and harmonious of the epoch. ...' (*La Vie Moderne*, 19 June 1879).

The End of the Lunch captures a precise moment in time and yet its spontaneity is apparent, not actual. The grouping of the figures, the emphasis on the heads and hands created by the juxtaposition of light and dark areas, and the delicacy and care with which the still-life objects on the table are painted all speak of deliberate and careful preparation and execution.

Fig. 28
The Luncheon

OIL ON CANVAS, 50 × 61 CM. 1879. MERION, PENNSYLVANIA, BARNES FOUNDATION

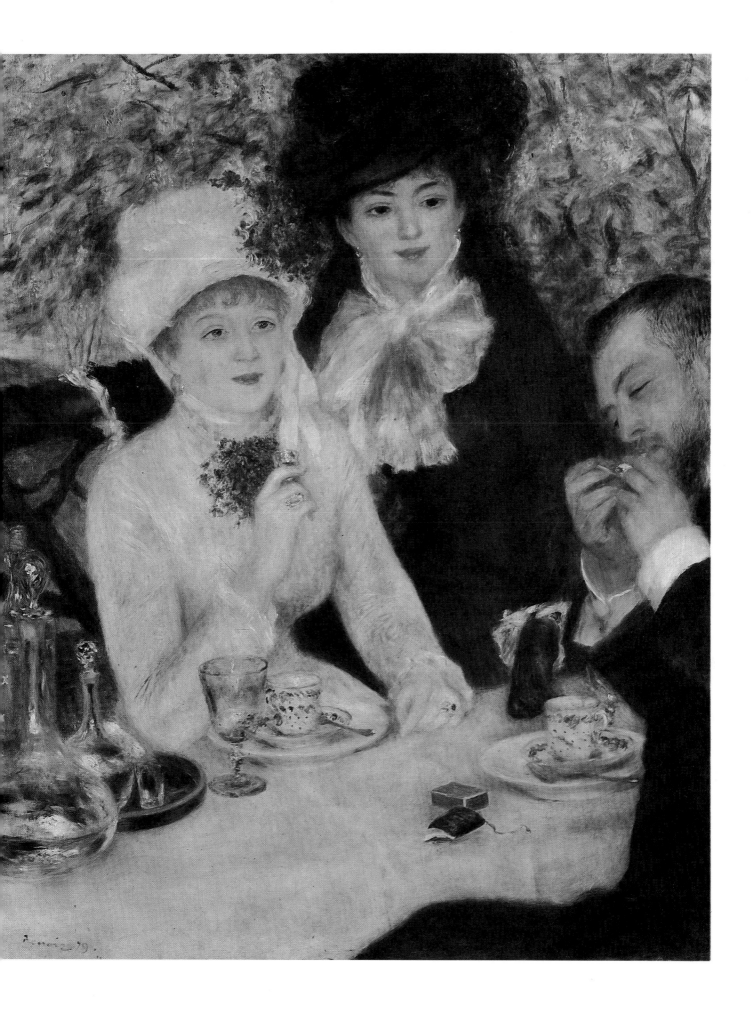

Woman with a Fan

OIL ON CANVAS, 65 × 50 CM. C.1880. LENINGRAD, HERMITAGE

This is a portrait of Alphonsine Fournaise, who posed for Renoir on at least six other occasions between 1875 and 1881. She was the daughter of Alphonse Fournaise, owner of the restaurant on the Île de Chatou that was the setting for *The Luncheon of the Boating Party* (Plate 36).

The painting, with its emphasis on rhythmic curves and the simplicity of its background, suggests Renoir's admiration for the Spanish masters Goya and Velázquez. Renoir's enthusiasm for their work was increased some years later when he visited Spain with his friend Paul Gallimard.

Renoir was pleased with his approach to this portrait. In October 1885 he wrote to Durand-Ruel that he had lost much time in finding a manner that satisfied him. Three weeks later he wrote, 'I am working and have some things under way in the manner of the *Woman with a Fan.*'

The painting was exhibited at the seventh Impressionist Exhibition after Renoir had decided with some reluctance to show his work. He had not exhibited at the three previous Impressionist exhibitions, and he only agreed to do so on this occasion if his paintings were listed as having been loaned by Durand-Ruel. He wrote to Durand-Ruel: 'I hope indeed that Caillebotte will exhibit, and I also hope that these gentlemen will drop this ridiculous title *Indépendants*. I would like you to tell these gentlemen that I am not going to give up exhibiting at the Salon. This is not for pleasure but, as I told you, it will dispel the revolutionary taint which frightens me.'

The Luncheon of the Boating Party

OIL ON CANVAS, 127 × 175 CM. 1881. WASHINGTON D.C., THE PHILLIPS COLLECTION

In 1881 Renoir wrote to his friend Paul Bérard: '… I am doing a picture of a boating party that I have been itching to do for a long time. I'm not getting any younger and I didn't want to delay this little feast, for later I won't be up to the effort; it's hard enough already. … It's a good thing from time to time to attempt something beyond one's powers.'

As in *The Moulin de la Galette* (Plate 26), Renoir's friends posed for him. In the foreground, fondling the dog, is Aline Charigot. Standing behind her is Alphonse Fournaise, proprietor of the restaurant on the Ile de Chatou where Renoir depicted this informal lunch. On the right, sitting astride the chair is Gustave Caillebotte talking to Ellen Andrée, and leaning over them is the journalist, Maggiolo. In the centre, raising a glass to her lips, is 'la belle Angèle', and behind her the financier Charles Ephrussi is seen talking to Alphonse Fournaise Junior. Leaning on the balcony is Alphonsine Fournaise and on the extreme right is Jeanne Samary talking to Paul Lhote and Lestringuez.

Shown at the seventh Impressionist Exhibition, this large canvas captures Renoir's enjoyment of life and displays not only his ability to show 'la vie moderne' to its full advantage, but also his virtuosity in rendering the still-life group in the centre foreground. The painting shows none of the restlessness and dissatisfaction with impressionism that Renoir was beginning to express by more frequent travelling and, shortly afterwards, by a change in pictorial style.

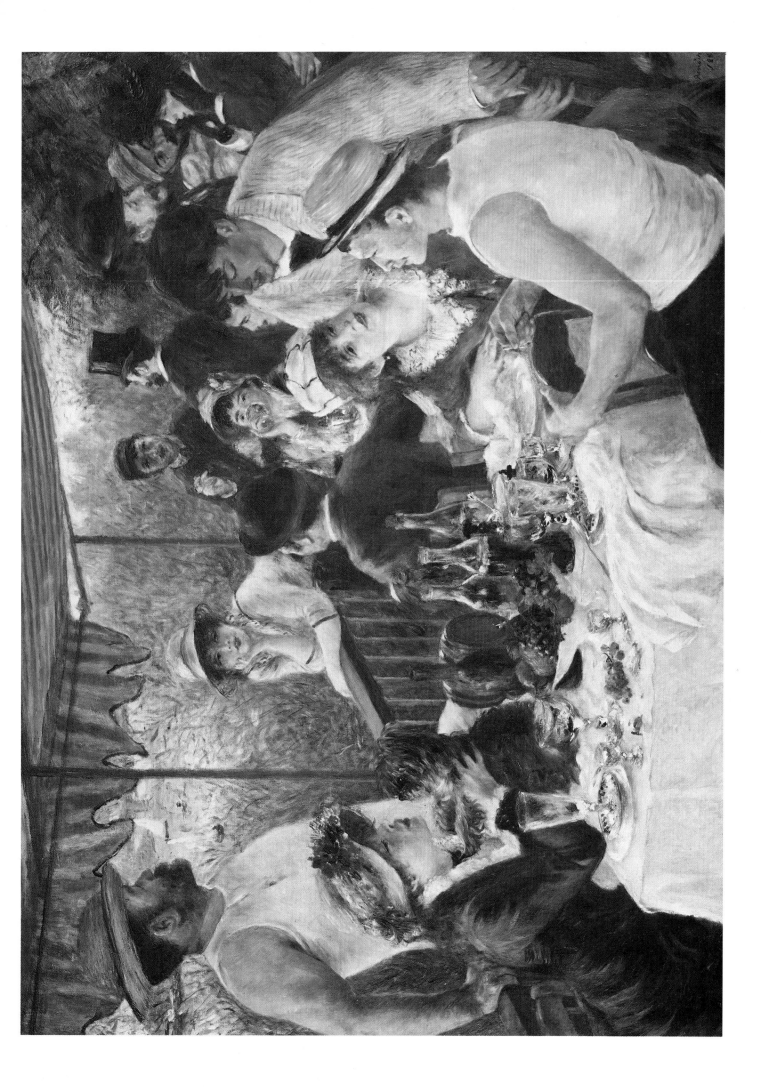

Fantasia, Algiers

OIL ON CANVAS, 73 × 92 CM. 1881. PARIS, LOUVRE (JEU DE PAUME)

Renoir went to Algeria early in 1881 with Frédéric Cordey. They were joined there by Paul Lhote and Lestringuez. Renoir wrote to Théodore Duret on 4 March: 'I wanted to see what the land of sun was like. I am out of luck, for there is scarcely any at the moment. But it is exquisite all the same, an extraordinary wealth of nature.' To Durand-Ruel he wrote: 'I am working a little. I am going to bring back some figure painting, but this is getting more and more difficult as there are too many painters around.'

The weather improved and he extended his stay in order to paint more of 'this marvellous country', where, as he said, 'the magic of the sun transforms the palm-trees to gold … and the men look like Magi kings.'

The *Fantasia* is a homage to Delacroix, whom Renoir admired greatly. The swirling crowds of figures are unusually small for Renoir in relation to the picture format, and convey a mood of excitement. A sense of the brilliant light is created by the use of juxtaposed areas of complementary colours, violet shadows on the yellow ground.

Renoir returned to Algiers in 1882 but after this visit he no longer worked within the long-established tradition of French artists paying tribute to the Orient, and Georges Rivière observed that exotic surroundings inhibited rather than stimulated him.

Dance at Bougival

OIL ON CANVAS, 179 × 98 CM. 1883. COURTESY, MUSEUM OF FINE ARTS, BOSTON. PURCHASED, PICTURE FUND

In about 1882 Renoir painted three pictures with dancing as their theme, the other two being *Dance in the Country* and *Dance in the Town* (both Paris, Louvre), which were commissioned by Durand-Ruel as decorative panels for his home. The male model for all three was Paul Lhote. In *Dance in the Country*, the female model was Aline Charigot, while in *Dance in the Town* and this painting, the model was an acrobat from the Circus Molier called Maria Clémentine. Under the pseudonym Suzanne Valadon she became a well-known painter, and she was the mother of Maurice Utrillo.

A pen-and-ink drawing of the *Dance at Bougival* (Los Angeles, Norton Simon Collection) is inscribed in Renoir's own hand: '*Elle valsait délicieusement abandonée entre les bras d'un blond aux allures de canotier.*'

The handling of the skirt and the change in direction of the brush-strokes describing the rough earth floor suggest the swirling movement of the waltz. Details like the cigarette butts and matches and abandoned bunch of violets evoke the informality of the setting.

The roughly parallel brush-strokes of the foliage at the top of the canvas are reminiscent of Cézanne's so-called 'constructive stroke'. Renoir had paid an extended visit to Cézanne at L'Estaque shortly before this painting was begun in the autumn of 1882.

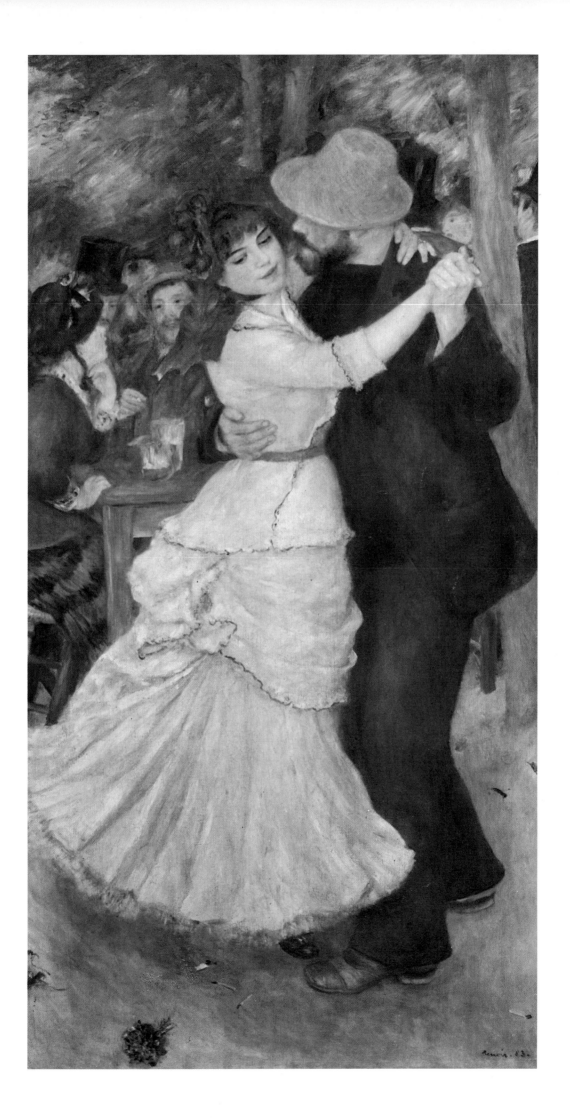

The Umbrellas

OIL ON CANVAS, 180 × 115 CM. C.1881-6. LONDON, NATIONAL GALLERY

This painting clearly shows the change in Renoir's style that occurred in the early 1880s. It is a painting that Renoir struggled to resolve, and as Martin Davies points out in the National Gallery catalogue, the canvas has been cut and a portion of it turned over the stretcher, thus altering the original proportions.

The girls on the right and the woman behind them are in Renoir's 'Impressionist' manner. Then, as Renoir told Ambroise Vollard, 'About 1883 a kind of break occurred in my work. I had gone to the end of impressionism and I was reaching the conclusion that I didn't know how either to paint or to draw. In a word, I was at a dead end.' The earlier part of the canvas can be dated on the evidence of the costumes worn c.1881/2, while the woman with the bandbox on the left can be dated c.1885/6. During the years that had elapsed between the painting of the two portions of the canvas, Renoir had studied masters of line like Ingres and Raphael, and he began to stress line and internal modelling of form instead of blurring the division between one form and the next in the impressionist style.

The umbrellas create a formal linking rhythm which is similar to that employed by Caillebotte in his large canvas *Rue de Paris, A Rainy Day* (Fig. 29).

Fig. 29
GUSTAVE CAILLEBOTTE
Rue de Paris, A Rainy Day

OIL ON CANVAS, 212.1 × 276.2 CM. 1877. THE ART INSTITUTE OF CHICAGO, CHARLES H. AND
MARY F.S. WORCESTER COLLECTION

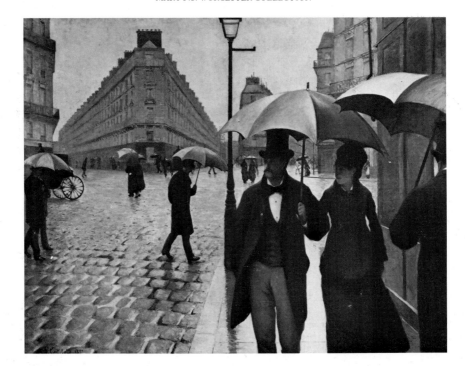

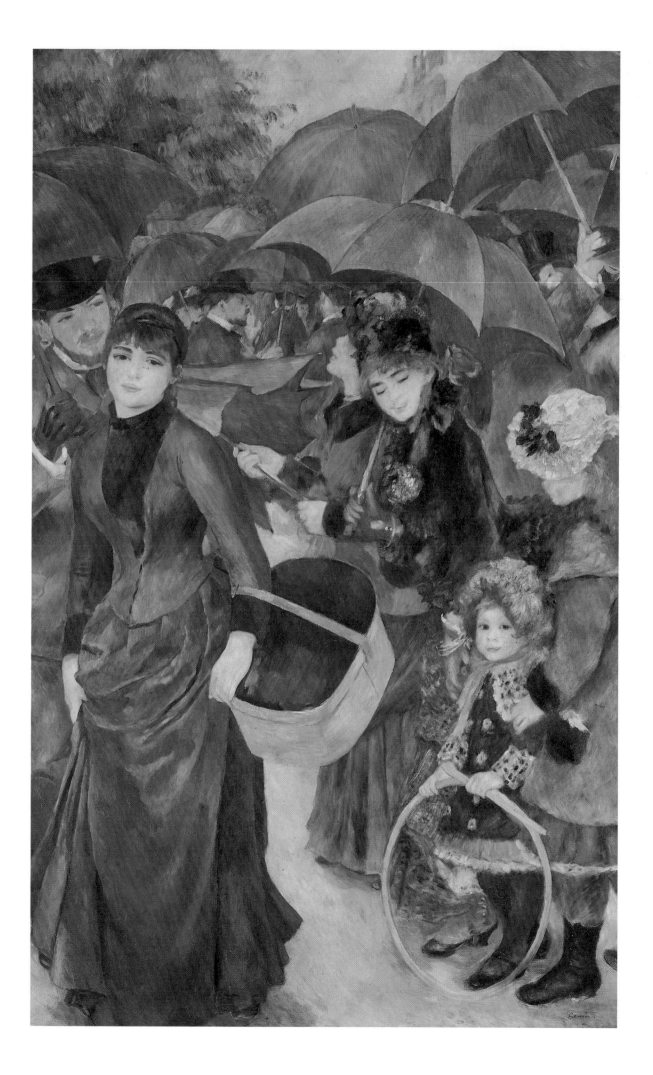

The Bathers

OIL ON CANVAS, 115 × 170 CM. 1884. PHILADELPHIA, MUSEUM OF ART (MR AND MRS CARROLL S. TYSON COLLECTION)

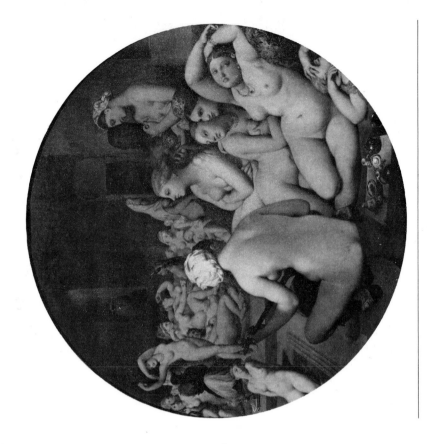

Fig. 30
JEAN-AUGUSTE-DOMINIQUE INGRES
The Turkish Bath

OIL ON CANVAS, DIAMETER 108 CM. 1859-63. PARIS, LOUVRE

Renoir exhibited this major painting at Georges Petit's gallery in 1887 under the title *Baigneuses. Essai de peinture décorative*. He made at least nineteen preparatory studies for it over a period of three or four years, and he told Berthe Morisot that the nude appeared to him to be one of the vital forms of art. He was delighted at the painting's considerable success, and wrote to Durand-Ruel, 'I think I have advanced a step in public approval, a small step ...'

Not everyone was convinced of the painting's merits. Camille Pissarro told his son Lucien: 'I do understand what he is trying to do, it is right and proper not to want to stand still, but he chose to concentrate on line, the figures are all separate entities, detached from one another without regard for colour.'

The separation of the figures reflects Renoir's admiration for Ingres (Fig. 30), while an iron bas-relief at Versailles by Girardon, *Bathing Nymphs* (1668–70) inspired the poses of the figures. Renoir drew on other sources for this evocation of a timeless idyll, among them Jean Goujon's *Fountain of the Innocents* at Les Halles, Boucher's *Diana at her Bath* and Raphael's *Galatea*, which he had admired at the Villa Farnesina in Rome in 1881.

Whereas Renoir's impressionist paintings are concerned with the effects of light and colour at a particular moment, in this work the figures are generalized, harshly lit and precisely modelled studio paintings, curiously at variance with their landscape setting.

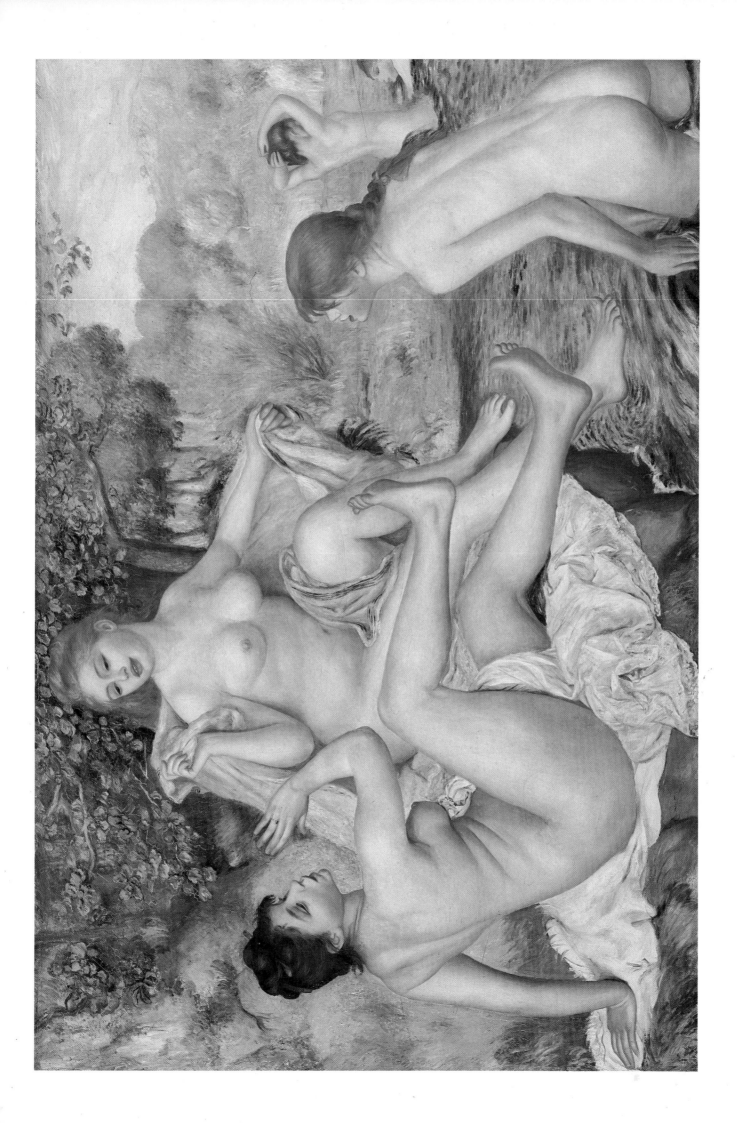

Seated Nude

OIL ON CANVAS, 80 × 63 CM. 1892. PRIVATE COLLECTION

Renoir began to suffer from arthritis in 1889, and from then until 1893 his output fell considerably as he endeavoured to redefine the direction of his art. In 1891 he wrote, 'Four days ago I was fifty and that's a bit old for a man to be seeking the light. But I have done what I could, that is all I can say.'

Renoir's *manière aigre* (harsh manner) was short lived, but he continued to paint nudes, which became the favourite subject of the latter part of his life. This nude is one of many similar variants on the theme of a young girl seated in an unspecific landscape. Monet owned a closely related painting (now in the Metropolitan Museum, New York) of the same date and apparently of the same model. He pointed out to a visitor the discrepancy between the figure and the background, saying, 'Yes, the nude is beautiful, but look how conventional the landscape is – it looks like a photographer's décor!'

The cliffs in the background of this painting are clear and may have been painted at Pornic on the Atlantic coast, where Renoir spent the summer of 1892, but Renoir pays more attention to details such as the rounded, pearly-toned knee of the girl, who appears to have been painted in the studio.

Renoir's preoccupation with the same subjects after 1880 led him to say to his son Jean: 'Maybe I have painted the same three or four pictures all my life! One thing is certain, since my trip to Italy I've been concentrating on the same problems!'

At the Piano

OIL ON CANVAS, 116 × 90 CM. C.1892. PARIS, LOUVRE (JEU DE PAUME)

Many of Renoir's paintings of this period are of two girls, absorbed in an occupation such as playing the piano or looking at a book; they may owe something to Renoir's close friendship with Berthe Morisot, Madame Eugène Manet, in the early 1890s. He spent considerable time with the Manets, at their country home at Mézy on the Seine and in Paris, and in some of the paintings of the time, Julie Manet, Berthe Morisot's daughter, acted as a model.

The girls are detached from the spectator, completely absorbed in their activity, and are observed with the gentleness and understanding to be found in Berthe Morisot's own work. Renoir's severely linear manner had disappeared by this time and forms merge with one another. The colour intensity of the painting is very high, with yellows, oranges and reds dominating, and the effect is one of luxury and ease, characteristic of Renoir's later work.

Durand-Ruel organized a large retrospective exhibition of Renoir's work in 1892, and this painting was purchased by Henri Roujon, Director of Fine Arts, at the instigation of Stephane Mallarmé, to form part of a permanent collection of the works of living painters in the Luxembourg Palace.

Fig. 31
At the Piano

OIL ON CANVAS, 93.7 × 71.4 CM. 1878. COLLECTION OF THE ART INSTITUTE OF CHICAGO, MR AND MRS MARTIN A. RYERSON COLLECTION

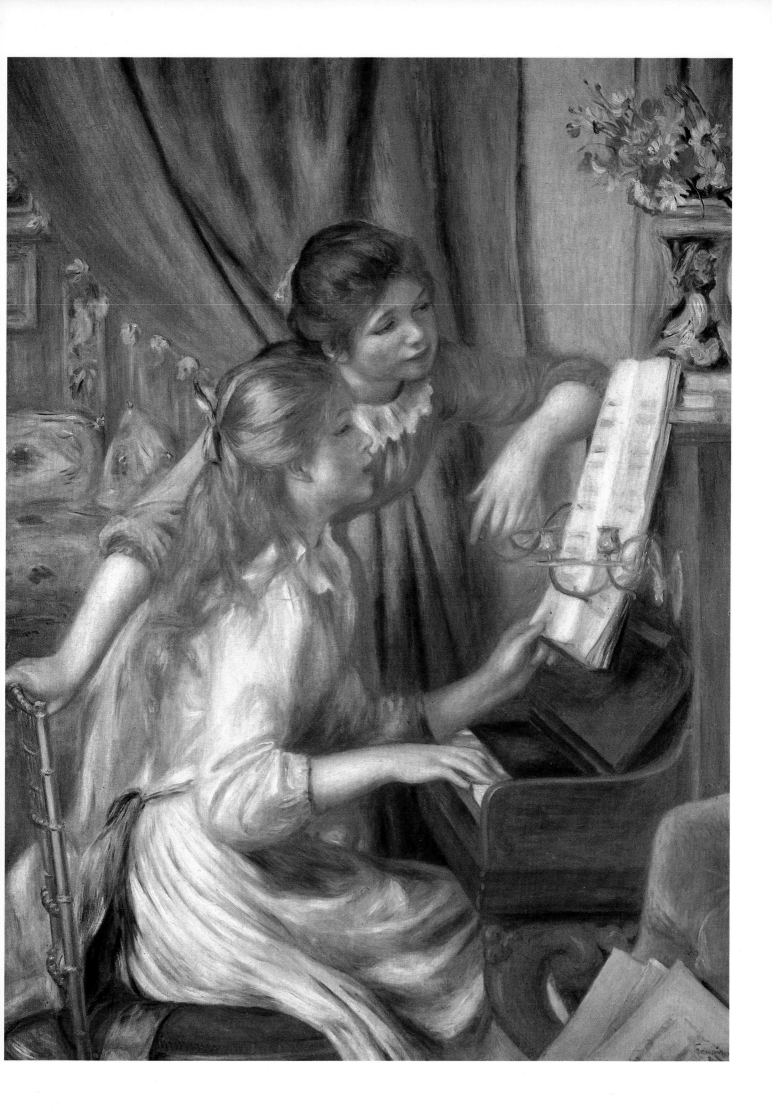

Portrait of a Young Woman in a Blue Hat

OIL ON CANVAS, 47 × 56 CM. C.1900. PRIVATE COLLECTION

Renoir's later paintings strongly emphasize the warm end of the colour spectrum, and in this portrait the glowing flesh tones, auburn hair and vivid orange background are heightened and accentuated by the addition of green in the background and in the roses that decorate the woman's dress. Drawn lines have disappeared and have been replaced by a concern with painted rhythmic curves, a sensuous movement of forms that heightens the languid sensuality of the face, with its heavy lips and cat-like eyes. As Renoir told his son Jean, 'Cats are the only women who count, the most amusing to paint.'

The painting is less a portrait of a specific woman than the artist's musing on form and colour, on the relationship between the curves of the hat and the contours of the face. At this stage of his career Renoir said, '[the model] is only there to set me going, to permit me to dare things I should never have thought of inventing without her, and to put me on my feet again if I should venture too far.'

Portrait of Ambroise Vollard

OIL ON CANVAS, 81 × 64 CM. 1908. LONDON, COURTAULD INSTITUTE GALLERIES

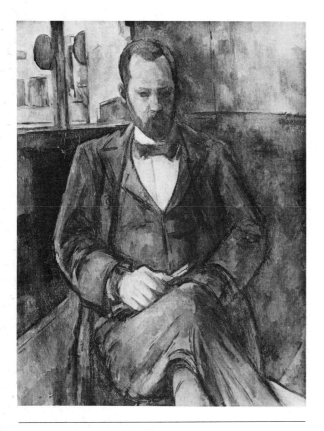

Fig. 32
PAUL CÉZANNE
Portrait of Vollard

OIL ON CANVAS, 100 × 81 CM. 1899. PARIS, PETIT PALAIS, MUSÉE DE
LA VILLE DE PARIS

Ambroise Vollard became an art dealer in Paris in the 1890s, with premises in the rue Laffitte. His taste was often uncertain, but he was willing to listen to advice and combined this with a shrewd commercial sense that made him successful. On Pissarro's insistence he sought out Cézanne and held the first exhibition of Cézanne's work in 1895. The following year he made a contract with Gauguin according to which he agreed to purchase all that Gauguin produced. Vollard met Renoir in 1894 and wrote a biography of him, which was first published in 1918. Renoir's friends claimed that Renoir often delighted in telling Vollard misleading anecdotes and that some of the conversations reported in his biography never took place.

Renoir painted Vollard on a number of occasions, once showing him flamboyantly dressed as a toreador. The warm tonality of this portrait is characteristic of Renoir's so-called 'red period', as is the concern with rounded curves. Renoir captures Vollard's interest in and enjoyment of the statuette by Maillol that he he is examining. In contrast to Cézanne's 1899 portrait of the dealer (Fig. 32) which required a hundred sittings, Renoir's more rapidly executed portrait shows Vollard relaxed and at ease. It is also in striking contrast to Picasso's portrait of some two years later.

Renoir presented the portrait to Vollard, and it was purchased by Samuel Courtauld in 1927.

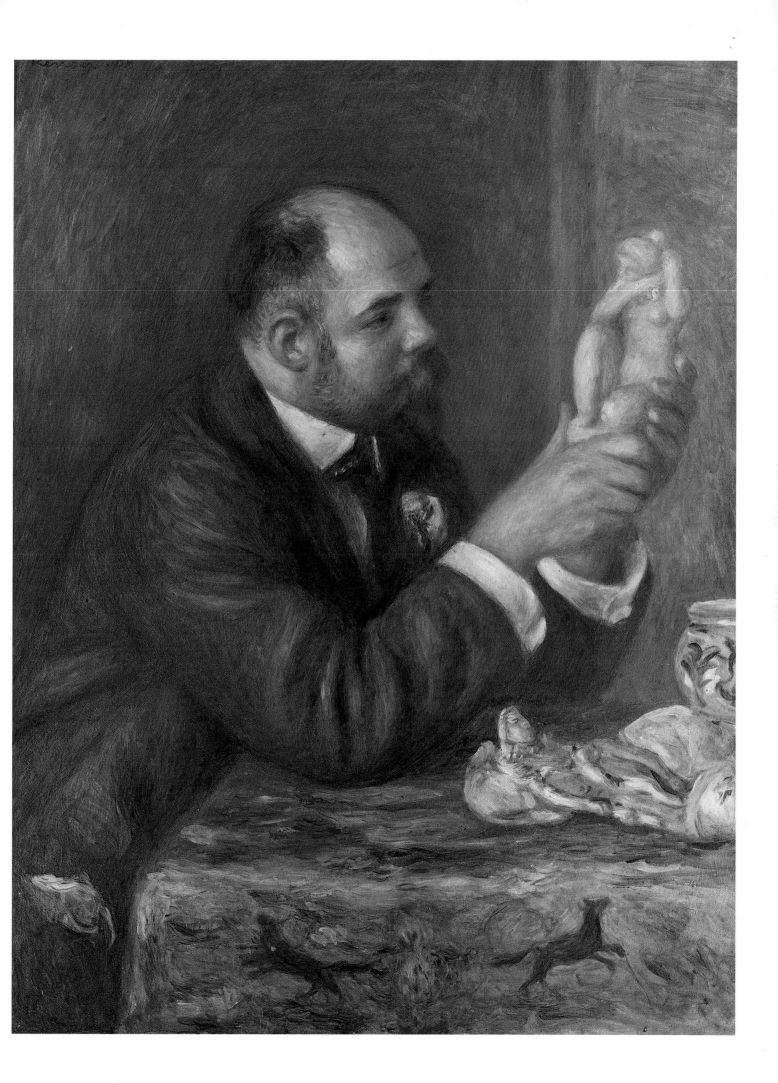

Dancing Girl with Castanets

OIL ON CANVAS, 155 × 65 CM. 1909. LONDON, NATIONAL GALLERY

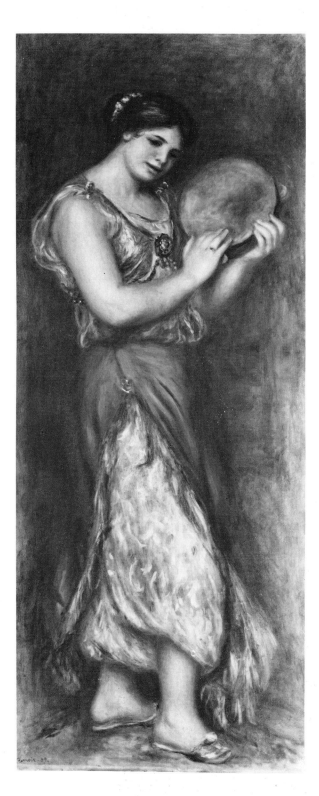

This painting and its companion piece *The Dancer
with a Tambourin* (Fig. 33) were painted as decora-
tions for the dining-room of the apartment of M.
Maurice Gangnat at 24 avenue de Friedland. The
model for the tambourin dancer and for much of this
picture was Georgette Pigeot, who recalled that it was
originally intended that the girls be shown bringing
in dishes of fruit. Between the spaces intended for the
pictures was a fireplace surmounted by a mirror, and
the family decided that it would be mistake to relate
the theme of the paintings too closely to the room in
case of a subsequent move. The head of the dancer
with castanets was modelled by Gabrielle, a servant
with the Renoir family and one of Renoir's most
frequent models.

Maurice Gangnat was an important patron of Re-
noir's in the latter part of the artist's career. Gangnat
was a successful industrialist who had retired to the
Côte d'Azur, and Renoir regarded him as a connois-
seur in the mould of Victor Chocquet. Jean Renoir
recalled: 'Whenever he [Gangnat] entered the studio
his gaze fell immediately on the canvas Renoir con-
sidered his best. "He has an eye for it!" my father
declared.'

The paintings display Renoir's concern with
rounded sensuous forms. Despite the staccato sug-
gested by their instruments, the rhythm of the two
works is harmonious and flowing, and reveals
Renoir's interest in classical antiquity, reawakened
by his move to the Mediterranean coast.

Fig. 33
Dancer with a Tambourin

OIL ON CANVAS, 154.9 × 64.8 CM. 1909. LONDON, NATIONAL GALLERY

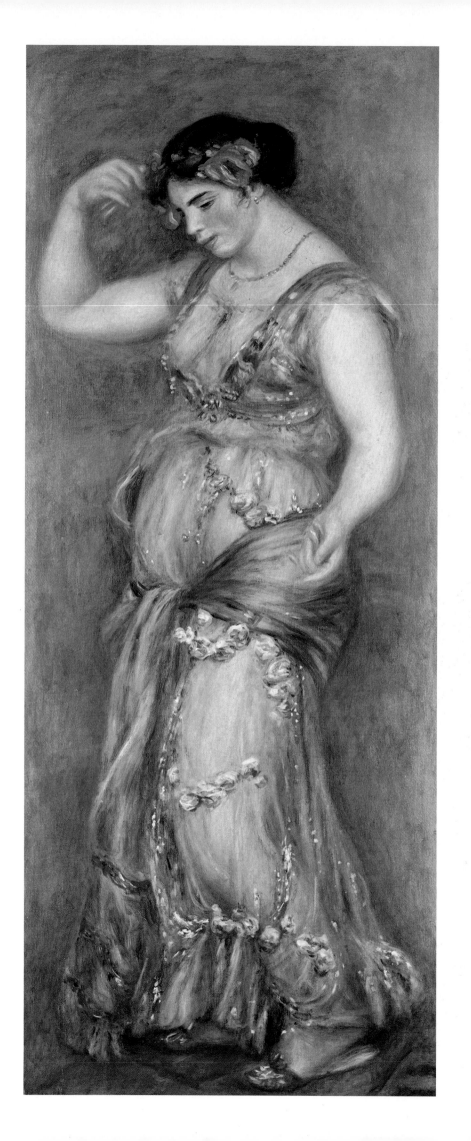

Nude Figures in a Landscape

OIL ON CANVAS, 40 × 51 CM. C.1910. STOCKHOLM, NATIONALMUSEUM

This small, sketchy canvas is characteristic of Renoir's late work in its subject-matter and in the opacity of the pigment. Renoir said to Joachim Gasquet shortly before his death: 'What admirable creatures those Greeks were! They lived so happy a life that they imagined the gods came down to earth in order to find their paradise and true love. Yes, the earth was the paradise of the gods. ... And that is what I wish to paint ...' Idealized figures in a landscape suggesting the colour and light of the Mediterranean dominate the last decade of Renoir's life.

These figures are not based on close observation. The heads are small, the hips exaggeratedly wide, and the emphasis is on rounded form, in the landscape background as well as in the figures. Renoir built up this roundedness in thin washes of semi-opaque pigment applied on a white ground. The technique is more reminiscent of watercolour than of oil-painting. The canvas grain shows through clearly, barely covered except in the white impasted areas.

This painting and other late nudes remind one of Renoir's admiration for Cézanne. Renoir owned four of Cézanne's oil-paintings and two watercolours, including *Nude Bathers* (1882-94).

Gabrielle with a Rose

OIL ON CANVAS, 55 × 46 CM. C.1911. PARIS, LOUVRE (JEU DE PAUME)

Gabrielle Renard was the daughter of a vine-grower from Essoyes, as was Renoir's wife Aline, and she was related to Aline's family, the Charigots. In 1894 Renoir hired Gabrielle, then aged sixteen, to help with the housework during Aline's second pregnancy. After the birth of Jean, Gabrielle remained with the family and became one of Renoir's favourite models. Renoir disliked professional models and Gabrielle had all the qualities he regarded as essential in a model. Her skin 'took the light', she had the small-breasted, wide-hipped body he preferred, she was natural and relaxed, and she was available to pose at any time. She even posed as the shepherd Paris, with a Phrygian cap on her head, for *The Judgement of Paris* (Fig. 35).

Roses appear constantly in Renoir's work from about 1896. The open curves of the petals and the range of pink and red tones fascinated him, and he told Vollard that the many paintings of roses were '... experiments with flesh tints that I make for my nudes.' (Fig. 34). Here the roses emphasize the rounded voluptuousness of Gabrielle's body and her clear, high-coloured skin tones.

Fig. 34
Roses in a Vase (detail)

OIL ON CANVAS, 29.5 × 35 CM. C.1900. PARIS, LOUVRE (JEU DE PAUME)

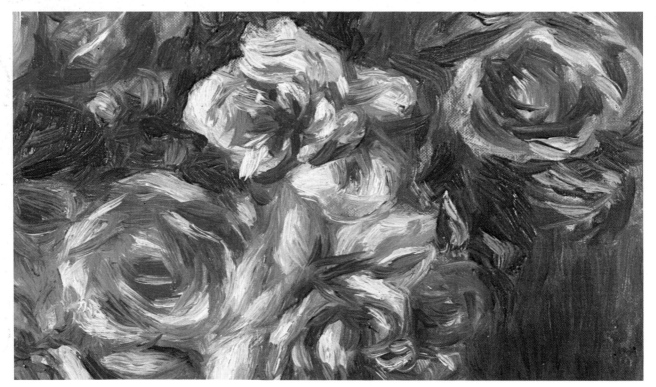

The Bathers

OIL ON CANVAS, 110 × 160 CM. C.1918. PARIS, LOUVRE (JEU DE PAUME)

This large canvas, which was painted in the year before his death, is Renoir's swan-song. The reclining nudes in the foreground are elongated to reinforce the horizontal emphasis of the format, and Renoir stresses curves and circular forms throughout: breasts, cheeks, elbows and knees are highlighted and clearly defined.

Renoir used a model for the figures – Andrée Hessling, known as Dédé, who later became his son Jean's first wife – but he moves far beyond the representation of any individual in the creation of an idyllic vision (compare Fig. 35).

Renoir accomplished the physical act of painting his late pictures with great difficulty. His hands were so crippled with the combination of arthritis and rheumatism which had afflicted him since the 1890s that he could no longer hold his brushes. They were strapped to his wrist and he moved about in a wheelchair. He had a special easel made for large canvases, a type of endless screen mounted on rollers that enabled him to work on the large scale he required. He had simplified his palette to white, Naples yellow, yellow ochre, raw Sienna, red ochre, rose madder, green earth, emerald green, cobalt blue and ivory black.

Neither his physical difficulties nor his grief at Aline's death in 1915 and his anxiety about his two sons in the army deterred Renoir, aged seventy-seven, from attempting to capture on this canvas his vision of an earthly paradise.

Fig. 35
The Judgement of Paris

OIL ON CANVAS, 73 × 91 CM. C.1915. GERMANTOWN, PENNSYLVANIA, COLLECTION HENRY
P. MCILHENNY